TREASURES OF ROMAN LINCOLNSHIRE

Antony Lee

AMBERLEY

For Cao Qin

First published 2016

Amberley Publishing
The Hill, Stroud
Gloucestershire, GL5 4EP

www.amberleybooks.com

British Library Cataloguing in Publication Data.
A catalogue record for this book is available from the British Library.

ISBN 978 1 4456 6470 5 (print)
ISBN 978 1 4456 6471 2 (ebook)

Typesetting and Origination by Amberley Publishing.
Printed in Great Britain.

Contents

Acknowledgements

One of the skills required of archaeological museum curators is the ability to synthesise information and disseminate it to a wider audience, taking archaeological data and interpreting it for a fascinated but often non-specialist audience through gallery interpretation, talks and tours. This book is an extension of that role, which I have been fortunate enough to hold for the past thirteen years, and I would like to record my gratitude to Lincolnshire's archaeological community – past and present, professional and amateur – as it is upon their hard work and discoveries that this book has been built. In particular, I would like to express my profound gratitude to Dr Adam Daubney, without whom this book would not have become a reality. Thanks are also due to all of my friends and colleagues at The Collection in Lincoln, particularly Dawn Heywood, William Mason and Dr Erik Grigg for their support and good humour over the years. My passion for the Roman period has always been inspired and supported by Dr Michael J. Jones, and my ongoing gratitude to him is deep. Finally to my wife, parents and grandparents, whose love and support cannot be overstated.

The author and publisher would like to thank the following people and organisations for permission to use copyright material in this book. The majority of images are courtesy of The Collection: Art and Archaeology in Lincolnshire (Lincolnshire County Council) and the Portable Antiquities Scheme. Images of the tombstones of Titus Valerius Pudens and Volusia Faustina are the copyright of the Trustees of the British Museum. Images of excavations by the City of Lincoln Archaeology Unit and its predecessors are reproduced courtesy of the City of Lincoln Council. Illustrations of inscriptions are reproduced by permission of the Administrators of the Haverfield Bequest. The maps of Lincolnshire were kindly produced by Dr Adam Daubney. Plans of the Lincoln forum, baths and traders' houses were drawn by Dave Watt and reproduced by permission of Historic England/City of Lincoln Council. Images of sites, excavations, finds and reconstructions have been generously provided by FAS Heritage (infant burial at Lincoln Castle), Pre-Construct Archaeology Ltd (inhumations at Newland, Lincoln), Navenby Archaeology Group/Ian Cox (Navenby excavation), Dr Adam Daubney (Riseholme barrow), the Lincolnshire Historic Environment Record/Richard Watts (Horncastle wall), the Society for Lincolnshire History and Archaeology (David Vale reconstructions), Dale Trimble (Sleaford alphabet sherd) and Tom Lane (saltern reconstruction). The images of the Flag Fen Iron Age roundhouse (Andrew Wilkinson)

and the Lincolnshire Wolds (Paul Stainthorp) are reproduced under CC BY-SA 2.0 licenses. The photograph of the *columbarium* of Pomponius Hylas was generously provided by Matthew Berry.

Every attempt has been made to seek permission for copyright material used in this book. However, if we have inadvertently used copyright material without permission/acknowledgement we apologise and we will make the necessary correction at the first opportunity.

Introduction

When the Roman legions invaded Britain in AD 43, Lincolnshire formed part of the lands of the Iron Age Corieltavi tribe. We do not know what the reaction of the tribal leaders was to the political and military upheaval facing them, to say nothing of how rural farming communities might have felt. Inexorably, however, they were drawn into the expanding embrace of Rome and became, willingly or unwillingly, part of the Roman Empire.

The Roman conquest was a momentous event in British history and is traditionally viewed as a positive one, bringing advances in technology, infrastructure and governance. Recent archaeological interpretations, however, have attempted to view the Roman period not from the perspective of the invader but of the individual, whatever their ethnic origins, and to investigate themes such as cultural identity, regionalisation and landscape variability as much as the grand monuments of empire; to examine the reality of people's lives, not merely the extent to which they became 'Romanised'. We use the term readily, but there is really no such thing as a 'Roman' outside of Rome itself. The Roman Empire encompassed a vast range of cultures and, although a Briton and a Syrian may have had things in common, their experiences of life under Rome will have differed. This book attempts to reflect this reality, seeing the Roman occupation of Lincolnshire as neither inherently good nor bad, but just one part of the county's continuous history. There was no single experience of 'Roman Britain', or indeed of 'Roman Lincolnshire'. The period was one of both cultural upheaval and continuity for different people at different times, with native and imported cultures interacting to form new hybrid societies and relationships.

This book aims to provide a thematic overview of life in Lincolnshire during the period, using archaeological objects and monuments, and placing them in the wider contexts of Roman Britain and the Roman Empire. The objects are both antiquarian and modern, found during formal excavation and by members of the public. Whether gold, stone or wood, they are all treasures. There are many more wonderful finds and stories that could not be included, but the book offers a starting point to discovering Lincolnshire's rich Roman heritage, and exploring how our understanding of the period has evolved over time, with the potential to continue to do so in the future.

1

Landscape and Coastline

1.1 The landscape of Roman Lincolnshire

Lincolnshire is a county with a diverse landscape. From the rolling Wolds to the expanse of the fenland, the agricultural vistas of central Lincolnshire and the spine of Lincoln Edge, the landscape has influenced human activity throughout history, changing

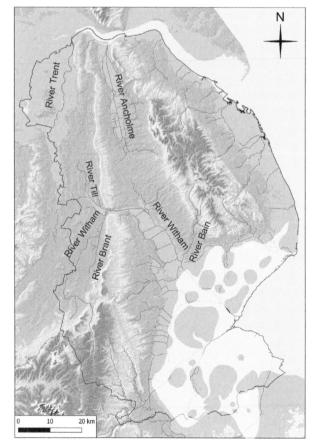

The major rivers and coastline of Roman Lincolnshire. (Dr Adam Daubney; Contains OS data © Crown Copyright and Land-Form Panorama data (2016))

through time and continuing to change today. Understanding landscape features such as rivers and the coastline in the past is fundamental to interpreting the context of finds and monuments, and how people interacted with the natural world. It is worth noting that the population of Roman Lincolnshire was small, with that of Lincoln estimated at around 5,000–8,000 and Lincolnshire in the tens rather than the hundreds of thousands. Towns were therefore the population equivalent of villages today, and the rural landscape sparsely populated.

The Roman coastline, particularly around the fens, was very different from today's, and people's ability to exploit it for settlement and natural resources varied (see 7.2 and 9.4). Silt deposition and peat formation made the landscape dynamic, and fenland 'islands' became foci for occupation. Rivers, not yet controlled by canalisation, were much wider than today and their flood plains affected the surrounding landscape. Recent surveys in the Witham Valley and the fens, including using aerial LIDAR (Light Detecting and Ranging) surveys, have begun to build a picture of the changing landscape through time in a way never before possible.

The Lincolnshire Wolds. (Paul Stainthorp)

2

The Roman Army
and Lincolnshire

2.1 The Roman army in Lincolnshire

The Roman invasion of AD 43 was just one step in a long-running relationship between Britain and the classical world. The Corieltavi tribe were on the northern fringe of a group of south-eastern tribes with the most contact with Rome, and it is possible that they were among the eleven who were recorded as submitting to Claudius without force. The Roman army, in the form of the IX Legion *Hispana* and accompanying auxiliaries, advanced into Lincolnshire in around AD 47 and remained a mobile force, establishing short-term 'marching camps' around the county. The fortress at Longthorpe near Peterborough was the legion's first long-term base. The River Trent became an important frontier, and camps established at Newton on Trent and across the river at

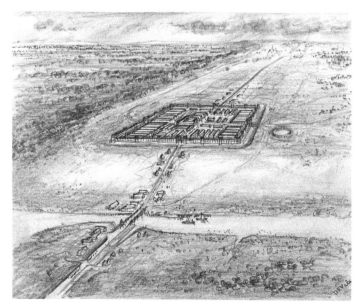

Reconstruction by David Vale of the IX Legion's fortress at Lincoln. (The Collection)

Rossington Bridge became the northern fringe of the entire empire, facing the hostile and unpredictable Brigantes tribe.

The hilltop fortress at Lincoln was not established until the AD 60s, possibly as part of the re-enforcement and redeployment of the IX Legion after losses suffered in the Boudican revolt. They garrisoned the area until around AD 72 when they advanced northwards to York and were replaced by the II Legion *Adiutrix Pia Fidelis*, who modified the fortress and remained until AD 77/78 before moving to Chester.

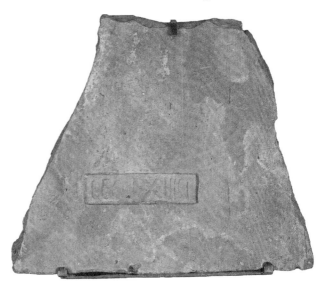

Roof tile from Lincoln, made by the IX Legion and stamped '*LEG IX HISP*'. (The Collection)

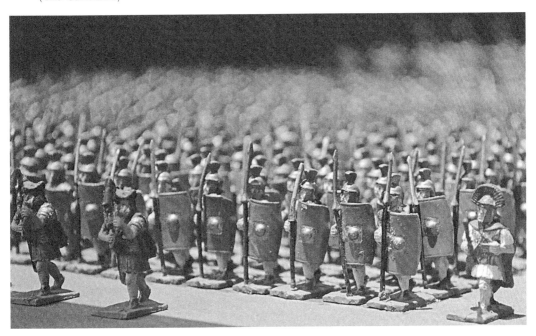

Model of the IX Legion in the archaeology gallery at The Collection. (Author)

2.2 The Roman army in the first century AD

The Roman army was a complex and hierarchical machine. Systems of organisation, rank and promotion were well defined, as were the roles and responsibilities of individual soldiers and officers. The army in the first century AD was divided into two basic types – the legions and the auxiliaries. The legions consisted of Roman citizen soldiers, the auxiliaries of non-citizens who performed more specialist roles such as archery and cavalry, often taking advantage of traditional ethnic military strengths. The legions were divided into ten cohorts, with the first cohort being the largest and most prestigious. Cohorts two to nine were divided into six centuries of eighty men, each commanded by a *centurion*. An entire legion had a theoretical strength of almost 5,500 men at the time of the invasion of Britain.

Each century had a *signifer*, a standard bearer to carry the *signum*, the rallying point of the unit in battle and a source of pride to be defended at all costs. The *signifer* was a trusted legionary, promoted to an important but dangerous job and paid double wages in recognition of this. His responsibilities included financial management for the century, including taking payments from his comrades to provide for their funeral if they died in service.

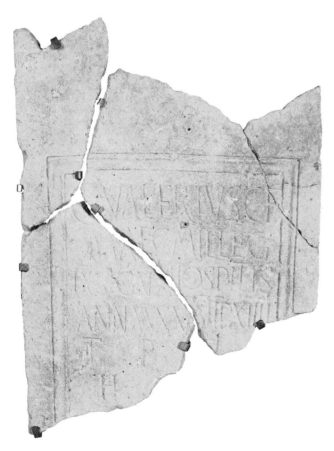

Tombstone of Gaius Valerius, *signifer* in the IX Legion, found at Lincoln. The inscription reads, '*G(AIVS) VALERIVS G(AI) F(ILIVS) MAEC(IA TRIBV) MIL(ES) LEG(IONIS) IX SIGN(IFER) C(ENTVRIAE) HOSPITIS ANN(ORVM) XXXV STIP(ENDIORVM) XIIII T(ESTAMENTO) P(ONI) I(VSSIT) H(IC) [S(ITVS) E(ST)]*'. This translates as, 'Gaius Valerius, son of Gaius, of the Maecian voting tribe, soldier of the Ninth Legion, standard bearer of the century of Hospes, aged thirty five, of fourteen years' service, left instructions in his will for this to be set up. Here he lies.' (The Collection)

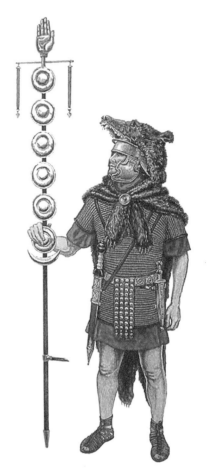

A Roman legionary *signifer.* (The Collection)

2.3 Legionary dagger sheath

This wonderfully preserved dagger sheath is one of the finest military items to have been found in Lincoln. It was excavated at East Bight in 1981, just inside the north-eastern defences of the legionary fortress. The sheath was found along with other military fittings and metalworking waste in a rubbish layer associated with the careful dismantling of the timber buildings of the fortress. It is possible, therefore, that the sheath was damaged and intended for recycling or repair. The sheath is made entirely of iron, which, combined with a coin of Nero found associated with it, dates it to the mid-to-late first century AD. Although completely corroded when discovered, x-rays and careful conservation have revealed panels of decorative inlay. Sheaths such as this may have been manufactured in specialist workshops on the Rhine frontier.

The dagger it contained was known as a *pugio*, a standard sidearm for legionaries and officers, most famous for being the weapon used by Julius Caesar's assassins. The quality of decoration might suggest that it was owned by an officer rather than a legionary, although we cannot be certain.

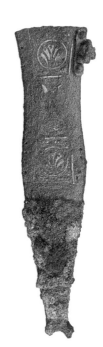

Inlaid *pugio* sheath from East Bight, Lincoln. (The Collection)

X-ray of the *pugio* sheath before conservation, showing the inlaid detail through heavy iron corrosion. (The Collection)

2.4 A band of international brothers

The greatest success of the Roman Empire was not its architecture, engineering, or military might, but its ability to accommodate vast cultural, ethnic and religious diversity within its embrace. The Roman army offered many opportunities for those willing to take the risks associated with a military life, including good standards of pay, healthcare, a retirement package and the chance to see the world. The Roman army of the first century AD was diverse, with soldiers of many cultural backgrounds fighting side by side. Even the small number of surviving tombstones from Lincoln reveal men originating from Macedonia, Italy, Spain, France and Hungary.

Titus Valerius Pudens was a soldier of the II Legion *Adiutrix Pia Fidelis* who died at the Lincoln fortress in AD 76. He was born in Savaria, a town in the Roman province of *Pannonia Superior* (modern Hungary). The II Legion APF recruited soldiers from the Roman navy, and the dolphins and trident motif on his tombstone suggest that Pudens was a sailor before joining the legion.

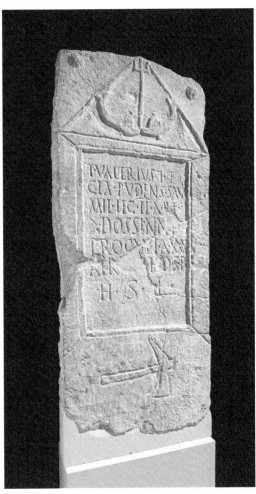

Tombstone of Titus Valerius Pudens. The inscription reads, '*T(ITVS) VALERIVS T(ITI) F(ILIVS) CLA(VDIA) (TRIBV) PVDENS SAV(ARIA) MIL(ES) LEG(IONIS) II A(DIVTRICIS) P(IAE) F(IDELIS) DOSSENNI PROCVLI A(NNORVM) XXX AERA [V]I H(ERE) D(E) S(VO) P(OSVIT) H(IC) S(ITVS) E(ST)*'. This translates as, 'Titus Valerius Pudens, son of Titus, of the Claudian voting tribe, from Savaria, a soldier of the Second Legion *Adiutrix Pia Fidelis*, in the century of Dossennius Proculus, aged thirty, of six years' service; here he lies. His heir at his own expense set this up.' (Trustees of the British Museum)

Military hinge, belt pendant and helmet crest holder, excavated at Lincoln. Despite their cultural differences, standardised equipment helped create solidarity among legionaries. (The Collection)

3

Roman Lincoln

3.1 The foundation of *Lindum Colonia*

When the II Legion *Adiutrix Pia Fidelis* moved to Chester in AD 77/78, the Lincoln fortress was carefully dismantled, leaving only the timber defensive walls and ditches intact (see 3.4). Although the army were no longer resident, the prominent hilltop site clearly remained the property of the Roman state. It stayed this way until the decision was taken to establish a veteran colony, a planned settlement to house retiring legionaries, on the site. The date that this foundation occurred is not clear, but we can calculate that it was between AD 84 and AD 96, and most likely in the early AD 90s during the reign of the Emperor Domitian. The early *Colonia* occupied the same footprint as the legionary fortress, but with stone walls replacing timber. The town subsequently expanded down the hillside and, in the late second and early third centuries, additional walls were constructed to enclose this lower settlement (see 3.5).

The inscription from Mainz (Germany) by Marcus Minicius Marcellinus commemorates the founding of a building to Fortuna and dates to between AD 81 and AD 95. Marcellinus states that he is from *Lindum*, and this is the earliest known reference to Lincoln's name. He was first spear *centurion* of the XXII Legion, a rank only attained after a full and distinguished military career. Marcellinus may have been born in the Lincoln area, and subsequently claimed citizenship of his birthplace when the *Colonia* was founded. It is evidence of how, although our focus is often on people from across the empire coming to Britain, Britons also took advantage of the opportunities offered by the wider Roman world.

Colonies do not come into the Roman state from outside nor grow from their own roots, but they are, as it were, propagated from the Roman state and have all the laws and institutions of the Roman people, not those of their own choosing. This condition, even though it is more exposed to control and is less free, is nonetheless thought to be preferable and more prestigious because of the greatness and majesty of the Roman people, of which these colonies seem to be almost small-scale images and reflections. (Aulus Gellius, *Attic Nights* 16.13.8–9)

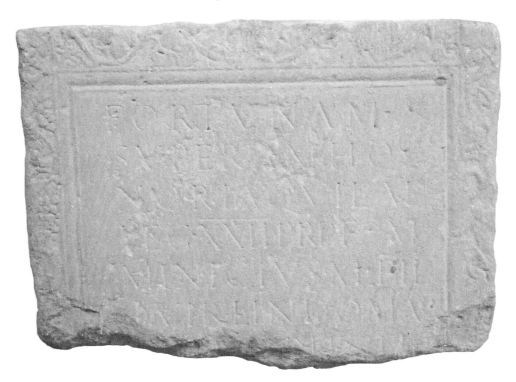

Cast of a dedication to Fortuna, set up in Mainz, Germany, by Marcus Minicius Marcellinus of Lincoln. The inscription reads, '*FORTVNAM SVPERAM HONORI AQVILAE LEG(IONIS) XXII PR(IMIGENIAE) P(IAE) F(IDELIS) M(ARCVS) MINICIVS M(ARCI) FIL(IVS) QVIR(INA) LINDO MAR[CEL]LI[NVS P(RIMVS)] P(ILVS) LEG(IONIS) EI[VS DEM]*'. This translates as, '[this structure] is dedicated to the honour of the goddess Fortuna by Marcus Minicius Marcellinus of Lincoln, son of Marcus, of the Quirina voting tribe, first spear *centurion* of the XXII Legion *Primigenia*.' (The Collection)

Gold *aureus* of Domitian, from Grimsby. (The Collection)

3.2 The forum and basilica

One of the least known of Lincoln's Roman monuments, the Mint Wall is actually a significant survival and one of the largest pieces of Roman building masonry to be seen in Britain. Its name is misleading, and comes from the antiquarian William Stukeley mistakenly associating it with the site of a coin mint. It was, in fact, part of the north wall of the basilica, the large public hall attached to the forum that served as the centre of government and commerce in the town. The open forum and its grand colonnade (marked by circular setts in the modern street surface of Bailgate) served as marketplace and public meeting area, on the classical principle that business deals should be concluded in public to be legally valid.

The forum was constructed on the site of the legionary headquarters building – the *principia*. Archaeological evidence for the original forum of the *Colonia* is fragmentary, but a paved surface with statue bases has been excavated (see 3.3). In the late second or early third century the forum underwent a major redesign, and it was at this point that the basilica (and Mint Wall) were constructed. The forum courtyard was surrounded on the other three sides by suites of rooms accessed via colonnaded porticoes.

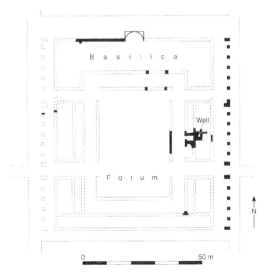

The Mint Wall. (Author)

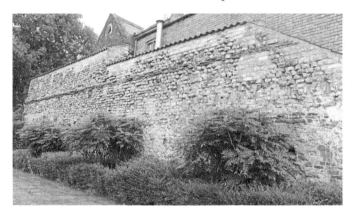

Plan of the late second/early third century forum and basilica. The solid areas are those attested archaeologically. (Historic England/City of Lincoln Council)

19

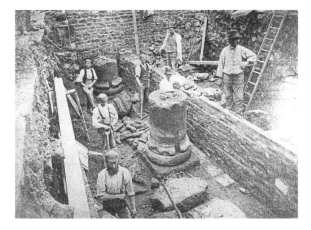

The discovery of the forum's eastern colonnade in Bailgate in 1878. (The Collection)

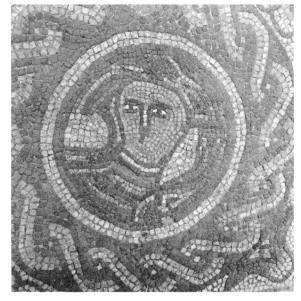

Mosaic fragment discovered in the forum in 1897, depicting a head and *cornucopia* within a circular border. Originally thought to be Autumn, it has recently been reinterpreted as Fortuna. (The Collection)

3.3 Imperial statuary

Bronze was a valuable metal in the ancient world and this, combined with its recyclability, means that only small amounts of bronze sculpture survive. We can be certain that public spaces in major towns such as Lincoln would have featured statuary of emperors, deities and prominent local citizens, but traces of those statues are rare. A life-sized horse foreleg, probably from an imperial statue, was discovered in Lincoln in the eighteenth century and was the only fragment of statuary known until the recent discoveries of an eagle wing, a human finger and further fragments of a horse.

Statuary was undoubtedly erected to honour the *Colonia*'s founder, Domitian (AD 81–96) but, after his assassination, he suffered *damnatio memoriae*, with his images torn down and his name erased. The Lincoln fragments, all bearing evidence of damage, may represent elements of Domitianic sculpture toppled at this time.

A cloak hangs from thy shoulders; the sword sleeps by thy untroubled side; even so vast a blade does threatening Orion wield on winter nights and terrify the stars. But the steed, counterfeiting the proud mien and high mettle of a horse, tosses his head in greater spirit and makes as though to move; the mane stands stiff upon his neck, his shoulders thrill with life, and his flanks spread wide enough for those mighty spurs; in place of a clod of empty earth his brazen hoof tramples the hair of captive Rhine. (Statius's description of an equestrian statue of Domitian at Rome, *Silvae* 1.1)

Bronze eagle wing from the first century with incised feathers, found during excavations at Lincoln Castle in 2013. The eagle was a symbol of Jupiter and an important imperial motif, often depicted surmounting a globe. (Lincolnshire County Council)

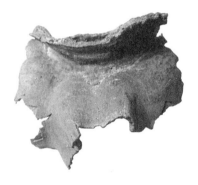 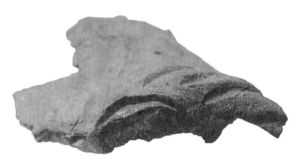

Fragments of an equestrian statue, found at North Carlton in 2010, from the horse's neck, muzzle and mane. (The Collection)

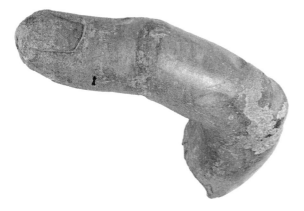

Slightly larger-than-life-sized bronze finger found in north-west Lincoln in 2015. (Portable Antiquities Scheme)

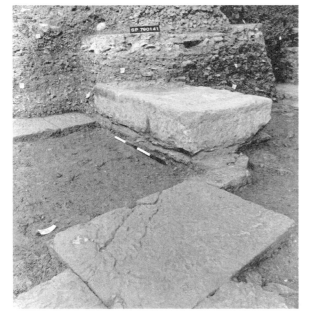

Excavations of the early *Colonia* forum, showing the paved area and a statue plinth. (City of Lincoln Council)

3.4 The Newport Arch and town defences

The Newport Arch is one of the most famous Roman monuments in Britain, and the only Roman arch in the country under which traffic still passes (although this has nearly been the cause of its demise in the past). Constructed in the early third century, the gate was the northern entrance into *Lindum Colonia* and stands on the site of the earlier gateway of the legionary fortress. It consisted of a single vehicular arch and two flanking pedestrian arches, the easternmost of which survives. The gate's working life continued into the medieval period and remains of this date still surround the Roman masonry.

Lincoln has more visible Roman gateways than any other town in Britain, with elements of the upper east gate, upper south gate, lower west gate and the pedestrian posterngate all also surviving and visible in the modern townscape. Sections of the town's impressive defensive walls can be seen on East Bight and adjoining the posterngate.

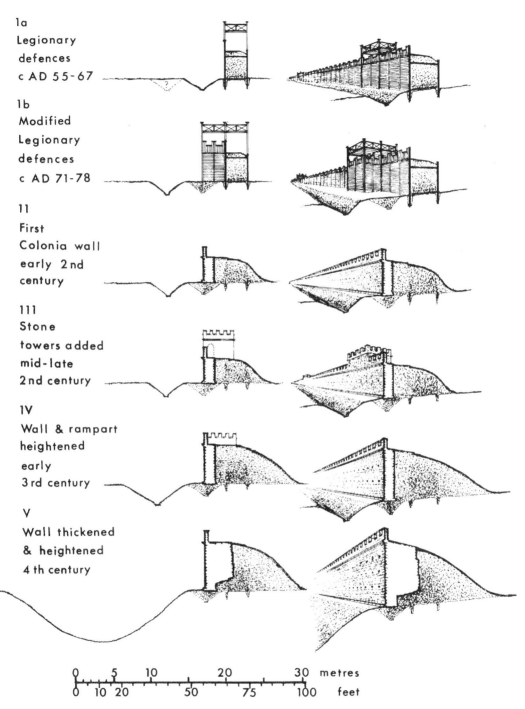

la
Legionary
defences
c AD 55-67

lb
Modified
Legionary
defences
c AD 71-78

11
First
Colonia wall
early 2nd
century

111
Stone
towers added
mid-late
2nd century

1V
Wall & rampart
heightened
early
3rd century

V
Wall thickened
& heightened
4th century

| 0 | 5 | 10 | | 20 | | 30 | metres |
| 0 | 10 20 | | 50 | | 75 | 100 | feet |

The development of the upper *Colonia*'s defences from the legionary fortress to the fourth century. (Dr Michael J. Jones)

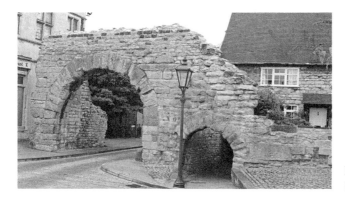

Newport Arch, Lincoln. (Author)

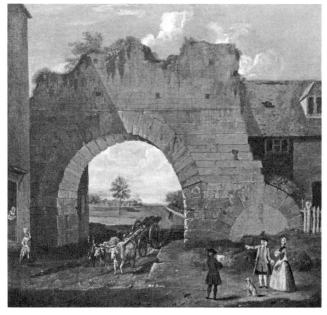

Newport Arch in *c*. 1756, by Nathan Drake. (Usher Gallery)

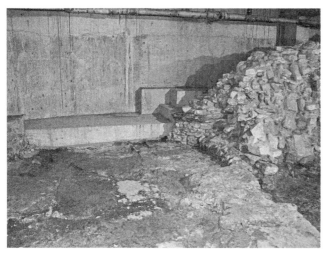

The posterngate, a pedestrian gateway built into the southern wall in the fourth century. (Dr Erik Grigg)

3.5 Traders' houses

The walls of Roman Lincoln were impressive structures, but we should not liken them to the walls of a medieval castle, designed to oppress and exclude. Instead, the walls projected the status of the town and provided barriers for the collection of tolls and taxes. Outside of the walls, cemeteries, certain dangerous or anti-social industries, and the shops and houses of traders lined the roads. Excavations at St Mark's, south of Lincoln along the line of Ermine Street, have revealed some of these commercial and domestic buildings, constructed in the earlier third century when previously waterlogged land had been reclaimed.

The buildings were thin strip buildings, built closely side by side with narrow frontages facing the street. Inside, the buildings were partitioned, perhaps into shop frontages with workshops behind and domestic areas at the rear. Traces of some trades have survived but it is difficult to ascribe a single industry to each building, which may in any case have changed through time. Evidence of querns, measuring stones, ovens and images of blacksmith's tools suggest baking, the sale of loose produce and metalworking.

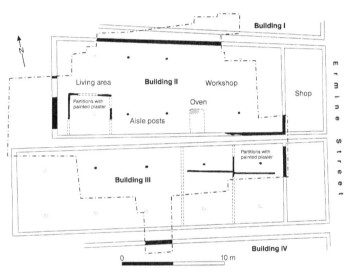

Traders' houses at St Mark's in the early third century. The simple layout and internal divisions can be seen, as can areas of painted plaster enticing potential customers into the shop. (Historic England/City of Lincoln Council)

The buildings contained ceramic sherds, decorated with images of metalworking tools. Such vessels may have been used in rituals to invoke gods of metalworking to protect the smith and his workshop. (The Collection)

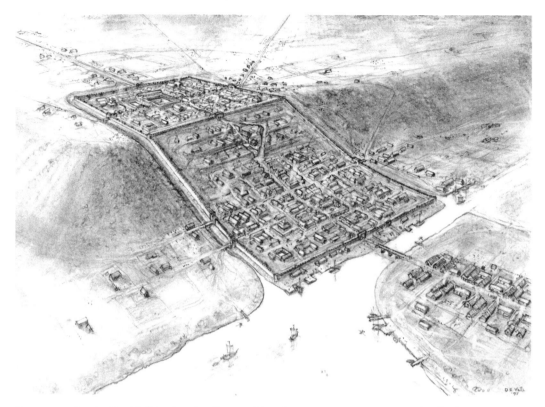

Reconstruction by David Vale showing Roman Lincoln at its greatest extent in the third century. The suburb with the traders' houses can be seen at the bottom right. (Society for Lincolnshire History and Archaeology)

3.6 Multiculturalism and ethnicity

An aspect of archaeology that is developing rapidly is the scientific study of individuals' ethnicity. Oxygen isotope analysis enables scientists to use tooth enamel to determine the composition of the water consumed when an individual was young and identify the area they grew up in. Studies of selected Romano-British cemeteries have suggested that anything up to 20 per cent of the burials may be people of non-British birth, although the results are not consistent nationally and further studies are required. The Roman Empire opened up opportunities for travel on a grand scale, through unified language, currency and political systems, and our understanding of just how cosmopolitan Roman Lincolnshire might have been is certain to grow exponentially in the future as techniques for analysing human skeletons are refined and applied to new discoveries.

The tombstone of Flavius Helius was discovered near Newport Arch in 1785, and was set up by his wife, Flavia Ingenua. The tombstone does not give us much of an insight into Flavius's life, aside from telling us that he was forty when he died, but it does highlight that he was Greek. Whether born in Greece or of Greek descent, it was clearly a defining element of his cultural identity.

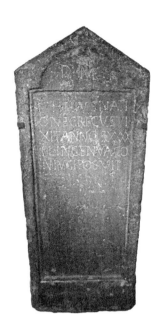

Tombstone of Flavius Helius. The inscription reads, '*D(IS) M(ANIBVS) FL(AVIVS) HELIVS NATIONE GRECVS VIXIT ANNOS XXXX FL(AVIA) INGENVA CONIVGI POSVIT*', which translates as, 'To the spirits of the departed and to Flavius Helius, a Greek by race, who lived forty years. Flavia Ingenua set this up to her husband.' (The Collection)

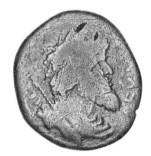

A silver *denarius* of the Numidian King Juba I, dated *c.* 60–46 BC and found in North Kesteven. Did coins like this arrive in Lincolnshire through trade, or were they carried by people arriving from North Africa? (Portable Antiquities Scheme)

3.7 International trade

Amphorae are vessels that typify the ancient world and its trade networks, and the sight of groups of these distinctive storage vessels is one of the iconic images of the Greco-Roman world. Decades of study of the distribution of *amphorae* of different forms and the goods they transported from various parts of the empire have enabled a better understanding of trade networks and the essential and luxury products available in the marketplaces of Roman Lincolnshire.

Lincoln has revealed the most evidence of imported products, but such goods would have filtered out to markets in smaller towns and rural areas. Analysis of the different types of *amphorae* being imported into Lincoln demonstrate ready markets for products such as wine, *garum* (a fermented fish sauce), olives, olive oil, figs, capers, dates and fish, imported from Spain, Gaul, Italy, Africa and the eastern Mediterranean. The greatest diversity of products occurred in the first and second centuries, but it is possible that in the later Roman period some products were being sourced more locally, or transported in wooden barrels, which leave less archaeological evidence.

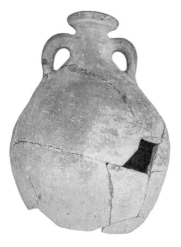

A Spanish wine *amphora* from Eastgate in Lincoln, found being re-used as part of a drain. (The Collection)

Fish storage tanks at a *garum* factory in Barcelona. Did the products of this factory ever find their way to Lincolnshire? (Author)

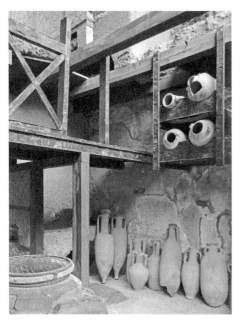

Amphorae at Herculaneum. (Author)

4

Major Settlements

4.1 Major Roman settlements in Lincolnshire

The Roman state recognised a number of formal designations for large towns, such as *Coloniae*, *Municipia* and *Civitas Capitals*, all of which reflected differing legal rights of residents, governance structures, regional and provincial responsibilities, and relationships with Rome. In Lincolnshire, only the *Colonia* at Lincoln had such a formal status and other larger settlements belong to a group known simply as 'small towns',

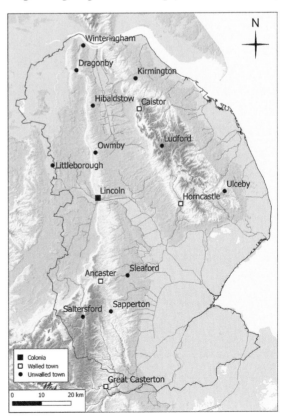

The major settlements of Roman Lincolnshire. (Dr Adam Daubney. Contains OS data © Crown Copyright and Land-Form Panorama data (2016))

although this modern terminology masks a wide range of settlement size, type, defences and specialised communities and economies.

Identifying the Roman names for specific towns can be problematic where epigraphic evidence does not exist. Thankfully, Roman 'maps' (known as 'itineraries') survive, giving the distances between settlements along set routes and enabling names and places theoretically to be reunited. This still requires interpretation, however, and associations have changed over time. *Causennae*, for example, was accepted as being Ancaster in the nineteenth century, but is now thought to relate to either Saltersford or Sapperton, and *Bannovallum* could just as easily be the name for Caistor as Horncastle, with which it is most commonly associated today.

4.2 Caistor

Caistor is located on the north-western edge of the Lincolnshire Wolds, and its modern name betrays its Roman origins, deriving from '*castrum*', meaning a fortified site. Although linked to the Roman town at Horncastle by the prehistoric trackway known as Caistor High Street, Caistor is not sited along the route of any known major Roman roads (see 9.1). The origins of the settlement are equally curious. Despite traces of the defences being identified for centuries, the existence of any pre-Roman occupation of the site is uncertain, and the nature of activity inside the walls is poorly understood. The defensive walls were constructed in the fourth century, later than those of most other Lincolnshire towns, and Caistor may have formed part of a late Roman defensive network (see 11.2).

Three miles south-south-east of Caistor, at Nettleton, metal detector finds and recent excavations have revealed evidence of occupation and ritual activity dating from the Iron Age into the Early Medieval period. Located near the highest point of the Wolds, the ritual aspects of the site are particularly significant, and votive finds have included finger rings with images of Vulcan and numerous miniature bronze weapons and shields.

Gold finger ring depicting Vulcan, god of smithing, holding tongs and a hammer over an anvil. Numerous such rings are known from Lincolnshire, with a concentration at the Nettleton site. (The Collection)

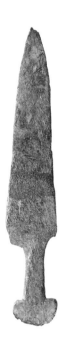
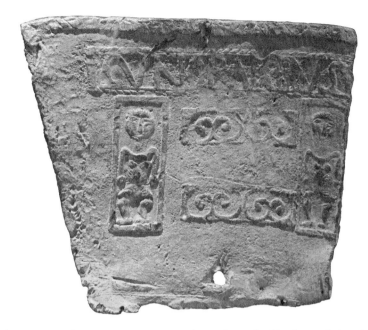

Above left: Miniature bronze sword, measuring just 5 cm long, from the Nettleton shrine site. (The Collection)

Above right: Lead tank fragment found inside Caistor's walls. Another part of this tank is in the British Museum. The full legend reads, '*CVNOBARRVS FECIT VIVAS*', meaning 'Cunobarrus made this, may you live happily'. See also 6.5. (The Collection)

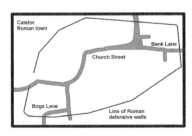
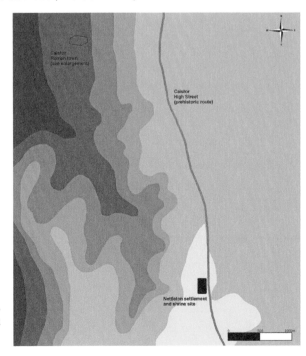

Plan of Caistor and its landscape. (Drawn by the author, based on Rahtz and Willis)

4.3 Great Casterton

Great Casterton is a site with a complicated and varied chronology. Located within a loop of the River Gwash, the earliest activity on the site was a military fort that was founded in the AD 40s and occupied for around thirty years, although slightly reduced in size during its final years of use. In common with many forts, a civilian settlement, a *vicus*, formed outside the walls, housing camp followers and locals drawn to the commercial opportunities offered by the soldiers. It was this *vicus* that formed the kernel of the town that grew up after the fort was dismantled although, as the town grew, it slowly shifted focus south-west towards the line of Ermine Street, which eventually came to run through the town. In the later first century a *mansio* (see 9.1) and accompanying baths were constructed in a prime position on this main thoroughfare. In the late

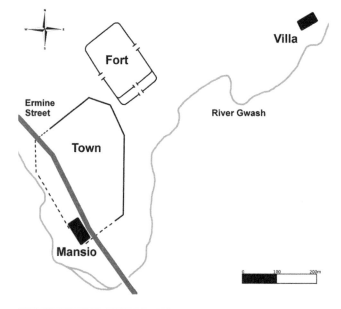

Plan showing the relative positions of the fort, town and villa. (Drawn by the author, based on Todd and Corder)

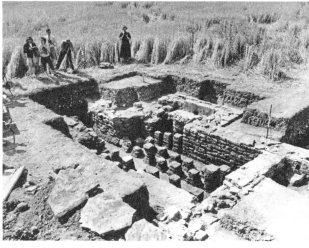

Excavations at the *mansio* baths, 1950s. (Stamford Museum collection)

second and early third centuries the town was enclosed with an impressive wall and ditch, made even more so in the fourth century through the expansion of the ditch and the addition of bastions large enough to house artillery. A grand villa was constructed a quarter of a mile to the north-east, the owner doubtless having close economic and social connections to the town.

4.4 Ancaster

Ancaster was a walled town lying directly on the line of Ermine Street, the major route passing through the centre of the town and forming its main road. The Ancaster gap has a complex archaeology, with an Iron Age settlement preceding the Roman town and the enigmatic triple-ditched enclosure known as Honington Camp on higher ground to the south-west. The earliest-known Roman activity is in the form of a marching camp north-west of the town and a possible fort immediately west of it. The town itself seems to have been founded in the mid-second century, and its prominence was confirmed through the provision of walls in the later second century and additional towers during the third. The walls enclosed an area of 9.1 acres, although occupation extended beyond the defences. The interior of the walled town is not currently well understood, with only traces of the street grid and buildings identified.

Despite its small size, Ancaster was a significant settlement. Its cemeteries are of particular archaeological interest, as large numbers of burials have been excavated when compared to other Lincolnshire towns. A group of around 300 late burials west of the town are significant, as they are orientated east-west and had few grave goods, leading to the suggestion that they represent an early Christian community.

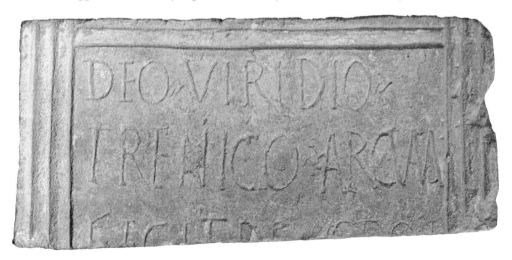

Ancaster was the site of a religious cult to a god named *Viridius*. This inscription was discovered in 1961 in the cemetery west of the town. It reads, '*DEO VIRIDIO TRENICO ARCVM FECIT DE [SV]O DONA[VIT]*', which translates as, 'To the god *Viridius*, Trenico has set up this arch at his own expense'. A further inscription to *Viridius* was discovered during excavations by *Time Team* in 2001. (The Collection)

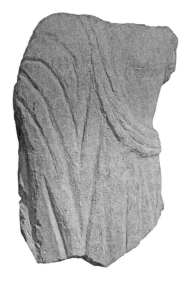

Life-sized stone figure depicting a man with a cloak draped over one shoulder. Discovered being reused as a grave cover, is it a depiction of *Viridius*? (The Collection)

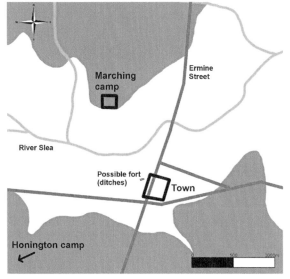

Plan of the Ancaster Gap. (Drawn by the author, based on Todd)

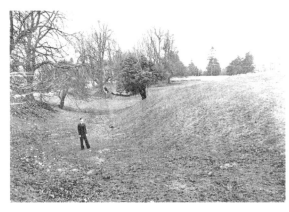

Ancaster's defensive ditch in 1954. (The Collection)

4.5 Horncastle

Located on the south-western Lincolnshire Wolds, Horncastle shares much in common with Caistor in terms of its development and its lack of connection to a major road (see 9.1). Iron Age finds suggest pre-Roman origins, with occupation continuing into the Roman period in the form of an extensive unwalled settlement to the south of the modern town centre. In the fourth century, as at Caistor, a small but substantial walled enclosure was constructed. At Horncastle it was located to the north of the unwalled settlement, at a strategic point at the confluence of the Bain and Waring rivers, suggesting that it was military in nature (see 11.2). Horncastle was closer to the sea in the Roman period than today (see 1.1), and may have overlooked and defended an area of the fens dominated by waterborne transport. Little is known of the interior of the walled enclosure, but excavations in recent years have begun to reveal more of the nature and extent of the unwalled settlement.

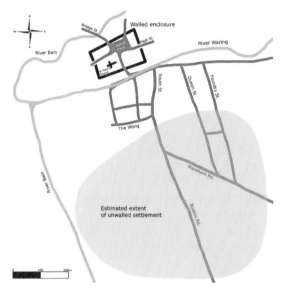

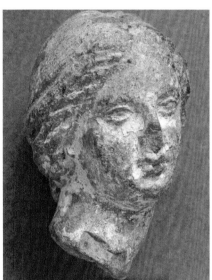

Above left: Plan of Roman Horncastle. (Drawn by the author, based on Field and Hurst)

Above right: Ceramic head from a small statuette, with traces of paint surviving. Found at Horncastle. (The Collection)

Right: Section of the Roman wall at Horncastle. (Lincolnshire County Council)

5

Rural Settlements

5.1 Farmsteads

Although towns and villas have historically attracted the most scholarly interest, the reality of life for the majority of people in Roman Lincolnshire was of small rural farmsteads and relentless agricultural labour. Lincolnshire contained large numbers of such farmsteads, often identified only through scattered surface assemblages of pottery and small finds, and rarely excavated. Recent research into these historically overlooked sites suggests that the majority of farmsteads in Lincolnshire were enclosed by ditches, to control livestock as much as for security. Most were already in existence in the late Iron Age and changed little after the invasion. For many of these rural communities, the impact of the arrival of Rome may have been very slight indeed.

Recent analysis of the agricultural activity being carried out on farmsteads across the East Midlands suggests broadly changing trends through time. There was, for example, a slight decline in pig breeding but a rise in cattle from the late Iron Age to the late Roman period. The choice of cereal crops remained generally static, although there was a rise in the amount of spelt wheat and oats being grown in the third and fourth centuries.

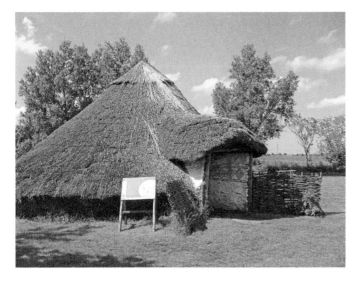

Reconstructed Iron Age roundhouse at Flag Fen. Buildings such as this continued to be used in the Roman period, and were only slowly replaced by rectangular structures. See also 5.3. (Andrew Wilkinson)

Surface finds such as ceramics, roof tiles, coins, shell, animal bone and metal small finds can indicate the presence of otherwise unidentified rural Roman farmsteads. It is important that such assemblages are recorded on the Historic Environment Record and with the Portable Antiquities Scheme. (The Collection)

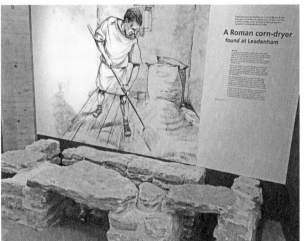

Reconstructed 'corn dryer' at The Collection. Consisting of a stone-built flue beneath a timber building, these agricultural structures may actually have been used for malting barley to make beer. (Author)

5.2 Navenby

Roman Lincolnshire contained numerous small rural settlements, larger than farmsteads but lacking the population, facilities or defences to be called towns. Mainly situated along road routes, our understanding of their distribution, economies and communities is steadily evolving. They clearly formed part of established trade networks between farmsteads and larger towns.

Navenby is located on the line of Ermine Street, approximately halfway between Lincoln and Ancaster. The Roman settlement began to be revealed in the 1960s and has recently seen a series of successful and innovative community and professional excavations, geophysical surveys and fieldwalking projects. A late Iron Age farmstead existed on the site, but the nature of early Roman occupation is uncertain. It has been suggested on military grounds that a fort may have lain nearby, but no archaeological evidence for it has yet been found. The civilian settlement was established by the mid-second century and, by its heyday in the fourth century, it occupied both sides of the road for around 900 m. Its location halfway between two major towns has led to the suggestion that a *mansio* may have existed there (see 9.1), providing the catalyst for the growth of the settlement.

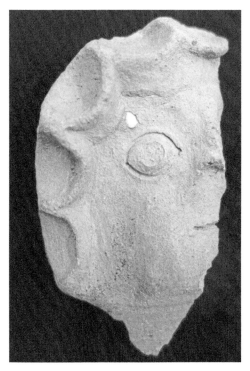

Ceramic face from a face neck flagon, of fourth century date and possibly made at Lincoln's Swanpool kilns. The face may represent a *Maenad* (a follower of *Bacchus*) and have been used in a shrine. (The Collection)

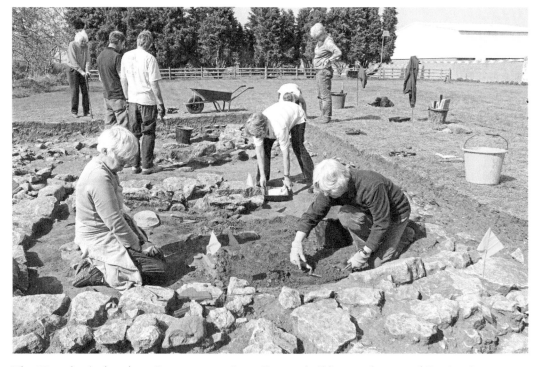

The Navenby Archaeology Group, excavating a Roman building to the east of Ermine Street. (Navenby Archaeology Group)

5.3 The villa at Winterton

The villa at Winterton in North Lincolnshire is one of a number of important small towns and villas located around Ermine Street as it approaches the River Humber. The site was identified in 1699, and excavations between the eighteenth and twentieth centuries have uncovered a number of buildings and mosaic pavements. The complex began life as a farmstead with circular buildings. Although roundhouses are traditionally seen as Iron Age structures, the Winterton villa is evidence of their continued use in the Roman period and, indeed, at Winterton they were stone built rather than wattle and daub. In the late second century the site began a dramatic transformation, the circular buildings replaced with rectangular ones and an elaborate decorative scheme introduced. By the mid-fourth century it had been transformed from a native farmstead into a culturally Roman villa, on a par with any in the country, and possibly related to the wealth of nearby ironworking industries.

Of the mosaic pavements at Winterton, the floor depicting Orpheus charming the animals is the most notable. Discovered in 1747, antiquarian illustrations are now the best record of its original appearance, particularly those by local builder William Fowler, who would go on to national acclaim for his illustrations of Roman discoveries (see also 8.4).

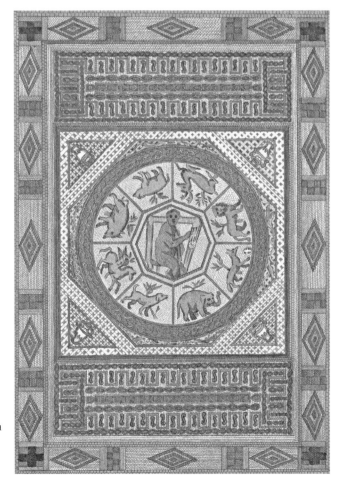

This page and overleaf: The mosaic depicts Orpheus with his lyre surrounded by (*anticlockwise from his feet*) an elephant, a fox, a lion, a stag, a bear, a boar, a winged horse and a hound. (The Collection)

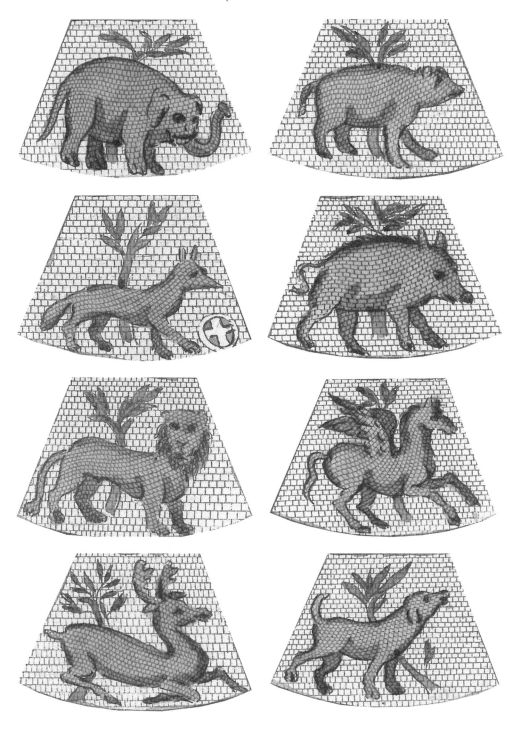

6

Religion, Death and Burial

6.1 Classical Roman religion

Classical Greco-Roman religion began to infiltrate Britain after the invasion, mainly through the military and the provision of temples in newly founded towns. Deities such as Minerva, goddess of wisdom, Mars, god of war and Mercury, god of merchants and trade were widely venerated in Roman Lincolnshire alongside the continued worship of traditional native deities. Greco-Roman religion emphasised the correct performance of ritual, meaning that the accuracy of words, gestures and omens during activities such as animal sacrifices were just as significant as the piety of the individual making the offering. Roman religion was essentially a contract between people and gods. The gods' help was sought and offerings promised if the god fulfilled their side of the bargain.

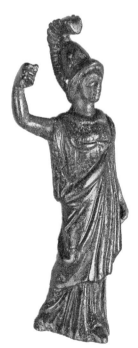

Bronze statuette of Minerva, found in
Lincoln Cathedral cloisters. (The Collection)

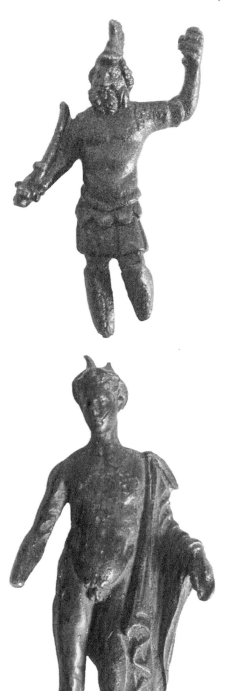

Bronze statuette of Mars, found at Keelby. (Portable Antiquities Scheme)

Bronze statuette of Mercury with winged hat (*petasos*) and a cloak draped over his shoulder. Found at Broughton. (The Collection)

42

The bronze statuette of the goddess Minerva shows her in her classical guise, robed but wearing armour and with a Corinthian helmet pushed back on her head. She originally held a spear and shield. It was found in Lincoln Cathedral's cloisters and the discovery of a similar statuette around 100 m away at Eastgate suggests a nearby shrine. Such small statuettes may have been offerings, or images of the goddess placed in niches.

6.2 Worshipping the Emperors

In AD 237 a businessman made a sea voyage from York to Bordeaux. Thankful for his safe arrival, he fulfilled the vow he had made before setting out by commissioning an altar to the protective goddess of the people of the Bordeaux region. The man was Marcus Aurelius Lunaris, priest of the Imperial Cult at Lincoln and York. The Imperial Cult was the official worship of the emperors. In the eastern empire, where the worship of living men as deities was accepted, this could mean the current emperor. In the west, however, the focus was on previously deified emperors and the *numen* (spiritual power) of the imperial office. Major towns such as Lincoln would have a number of priests (*Sevir Augustales*) to oversee the Imperial Cult, and a prominent temple (see also 10.2).

Priesthoods were not exclusive positions in the Roman world, being political offices as much as religious ones. A businessman such as Lunaris would have seen his local standing rise as a result of taking on such an important religious duty. Bordeaux was a centre of the wine trade, and Lunaris may have been in this industry, importing wine into the two *Coloniae* where he held office (see 3.7).

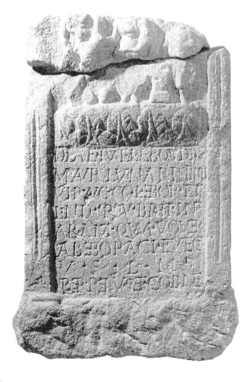

Cast of an altar set up by Marcus Aurelius Lunaris at Bordeaux and discovered in 1921. The frieze shows a bull being sacrificed. The inscription reads, '*DEAE TVTEL(A) E BOVDIG(AE) M(ARCVS) AVR(ELIVS) LVNARIS SEVIR AVG(VSTALIS) COL(ONIARVM) EBOR(ACI) ET LIND(I) PROV(INCIAE) BRIT(ANNIAE) INF(ERIORIS) ARAM QVAM VOVER(AT) AB EBORACI AVECT(VS) V(OTVM) S(OLVIT) L(IBENS) M(ERITO) PERPETVO ET CORNE(LIANO CONSVLIBVS)*'. This translates as, 'In honour of the protective goddess of the Boudigan people, Marcus Aurelius Lunaris, Sevir Augustalis of the *Coloniae* of York and Lincoln, in the province of Britannia Inferior, set up the altar that he vowed on starting from York. Willingly and rightly did he fulfil his vow, in the consulship of Perpetuus and Cornelianus'. (The Collection)

Detail of the Bordeaux altar inscription. (The Collection)

6.3 Native deities and the merging of beliefs

The Roman attitude to the native religions they encountered was an inclusive one. The polytheistic nature of ancient religion enabled parallels to be sought between deities, seeing them essentially as aspects of the same divine forces, merely known by different names and worshipped in different ways. In some cases Roman and native deities were conflated ('syncretised') and worshipped together. The most famous example of this in Britain is at Bath, where the presiding deity was a syncretisation of the native Sulis and the Roman Minerva.

This inscription originally adorned an arch into a shrine enclosure at Nettleham, just north-east of Lincoln. It records that Quintus Neratius Proxsimus, likely a citizen of Lincoln, had dedicated the arch in honour of Mars Rigonemetis and the Imperial Cult (see 6.2). The native deity Rigonemetis (meaning 'King of the Sacred Grove') may have been worshipped at the site in the Iron Age. In the Roman period, he was syncretised with Mars who, although known as a war god, originated as an agricultural deity.

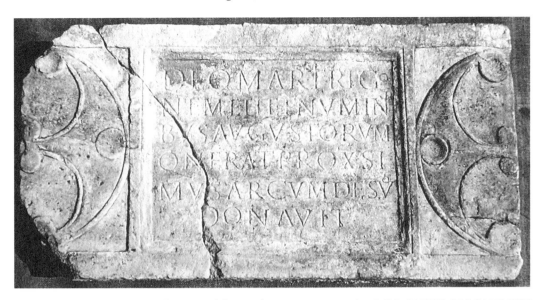

Dedicatory inscription from Nettleham. The inscription reads, '*DEO MARTI RIGONEMETI ET NVMINIBVS AVGVSTORVM Q(VINTVS) NERAT(IVS) PROXSIMVS ARCVM DE SVO DONAVIT*'. This translates as, 'to the God Mars Rigonemetis and the Divine Emperors, Quintus Neratius Proxsimus has given this arch at his own expense'. (The Collection)

Sceptre terminal depicting Mars, discovered close to the site of the Mars Rigonemetis inscription. Did it form part of the ritual regalia used at the shrine? (Portable Antiquities Scheme)

Three mother goddesses from Lincoln. Mother goddesses are found across Iron Age Europe, but actually seem to have been introduced to Britain during the Roman period. (The Collection)

6.4 Eastern cults and religious diversity

During the early empire, new religious ideas permeated the Roman world, mostly originating in the east in the form of cults dedicated to deities promising eternal salvation obtained through secret knowledge imparted to initiates. These cults were compatible with mainstream Roman religion, so a person could be an initiate into the cult of Mithras, Cybele or Isis and still make offerings to a Roman or native deity without feeling any conflict. The cults promoted personal piety and emotional involvement from their initiates compared with the focus on the correct performance of ritual stressed by mainstream religion (see 6.1). This attitude may have helped pave the way for the subsequent spread of monotheistic religions such as Christianity (see 6.5 and 11.3).

Firm evidence of people converting to these cults in Britain is rare, but their following may have been widespread, particularly in towns. This small bronze head is of Attis, companion of the Anatolian deity Cybele. In myth, Attis was unfaithful to Cybele and castrated himself in shame. Unable to stop him bleeding to death, Cybele turned him into a pine tree. Priests of Cybele, known as *Galli*, ritually castrated themselves in honour of Attis.

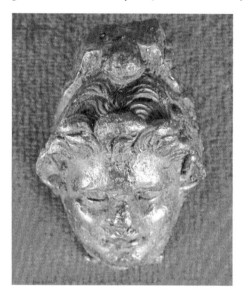

Bronze head of Attis, wearing a Phrygian cap, found at Lincoln. The head was originally mounted to another object, possibly an item of furniture in a shrine. (The Collection)

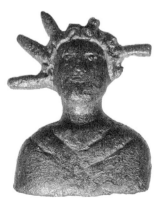
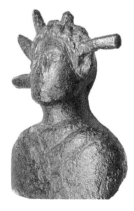

Bronze bust of *Sol* from Osbournby, dating to the third century. *Sol Invictus* (the unconquered sun) was closely associated with the worship of Mithras, whose cult was popular with soldiers. (Portable Antiquities Scheme)

6.5 Evidence of early Christianity

Archaeological evidence of early Christianity in Lincolnshire is scarce, but potential Christian burials (see 4.4), churches (see 11.3) and artefacts with Christian symbolism combine to suggest its presence. One object with potential Christian connections is a fourth-century lead tank from Walesby. Lead tanks are known from southern and eastern England, with five from Lincolnshire (see also 4.2), but their function is debated. Some, such as the Walesby tank, bear the Christian *Chi-Rho* symbol, leading to a suggestion that they were baptismal fonts. The Walesby tank also features a unique frieze with two groups of three figures, females on the left and males on the right, traditionally interpreted as a scene of full-immersion baptism.

The baptismal font theory has recently been challenged and the secular, imperial use of the *Chi-Rho* by the Emperor Constantine the Great highlighted. It may be that the symbol was a political one, highlighting imperial connections and personal ambition as much as Christian devotion. This is not to say that the Walesby tank was not a Christian object, but that the social and political connotations of such symbols were complex.

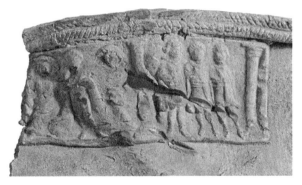

Lead tank fragment from Walesby, with an applied *Chi-Rho* (a monogram of the first two letters of 'Christos' in Greek) and a frieze possibly representing a baptism or native fertility deities. (The Collection)

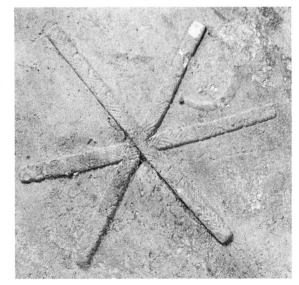

6.6 Magic, prayers and protective amulets

Away from the rituals of formal religion lay a world of superstition and magic, involving the control or pacification of occult forces unattributed to the worship of deities of any pantheon. Magic is difficult to define archaeologically but many artefacts from Roman Britain, including Lincolnshire, suggest that such beliefs existed. The wearing of protective amulets, the use of materials believed to have special properties and the writing of prayers and curses to influence events are all indicative of these beliefs. Amber, for example, was thought to help with poor eyesight and jet to relieve toothache. The electrostatic properties of jet also seem to have been valued, with charms made from it sometimes rubbed smooth.

A common example of a protective charm is the use of phallic imagery, and phallic pendants in bronze and bone have been found across Lincolnshire. The phallus was seen as an apotropaic symbol, warding off unseen bad fortune, and was particularly favoured by soldiers and worn by young children.

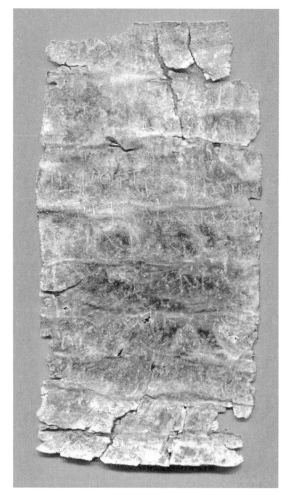

Lead plaque inscribed with a prayer in handwritten Latin. Originally tightly rolled, the plaque, found at a Roman farm at West Deeping, is a prayer for the womb of a woman named Clueomedes not to cause her harm. We can never know if this prayer successfully protected her. (The Collection)

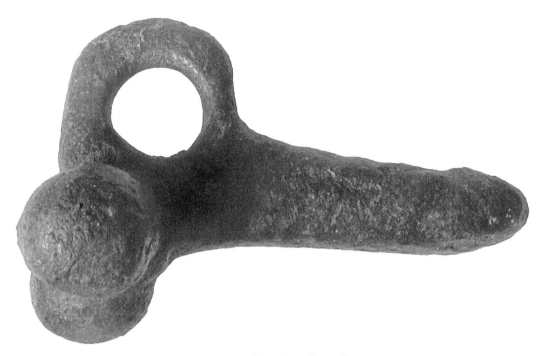

Copper-alloy phallic amulet, found at Sudbrooke. (The Collection)

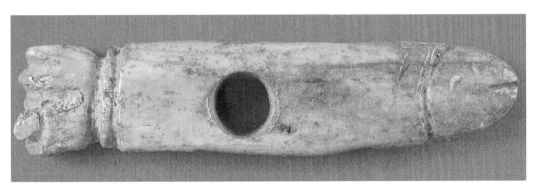

Bone 'fist and phallus' pendant, found at Lincoln. One end features a phallus and the other a fist making a gesture known as *manus fica*, itself intended to ward off bad fortune. (The Collection)

6.7 Burial practices

Changes in burial practice have occurred throughout human history and reflect evolving beliefs, cultures and fashions. Across Roman Britain, the general trend is that cremations were common in the first and second centuries, with inhumation becoming more popular and eventually dominating in the third and fourth centuries – although, in the East Midlands, archaeology reveals that inhumations were common,

even in the early Roman period. Within this broad pattern, wealth, local tradition and personal preference played a part. Many cremation burials were simple affairs with the remains of the deceased placed inside an urn (often a reused domestic storage jar), sometimes with accompanying food and drink offerings and the remains of items placed on the pyre.

Inhumations could be placed inside wooden coffins or stone sarcophagi, and the body either stretched out ('extended'), in a foetal position ('crouched') or face down ('prone'), although the cultural differences between these positions, if they existed, are not fully understood. Unusual actions such as removing the heads of the deceased ('decapitation burials') are not as common in Lincolnshire as in other areas (e.g., Oxfordshire), but even these strange practices seem to have been carried out respectfully and may reflect the continuation of the Iron Age veneration of the human head.

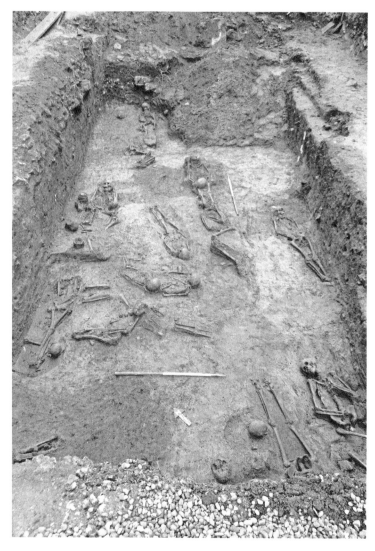

This group of inhumation burials was discovered in late 2015, close to Lincoln's waterfront, just south-west of the town walls. (Pre-Construct Archaeological Services Ltd)

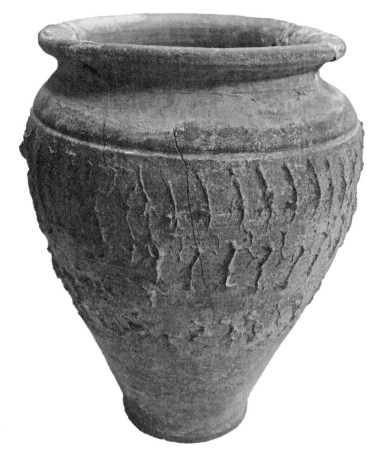

Cremation inside a
rusticated jar, found
at the south end of
Lincoln's High Street in
1904. (The Collection)

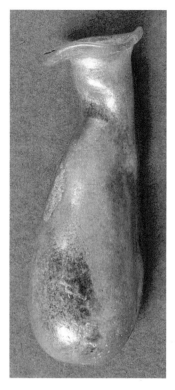

An *unguentarium* (glass phial for oils and perfumes), melted from being placed on a funeral pyre. The use of perfumes in funeral rites was probably common practice. (The Collection)

Burials in barrows – large earthen mounds – are rare in Roman Britain. The barrow at Riseholme, north of Lincoln, is the most northerly and earliest Roman example known. It contained a late first-century AD cremation burial with animal bone and ceramic and glass vessels. It is possible that the burial is that of a native aristocrat, buried in a manner reflecting pre-Roman cultural identity and practice. (Dr Adam Daubney)

6.8 Infant burials

Developments in medicine and our understanding of pregnancy and childbirth mean that infant mortality rates in modern Britain are incredibly low. In the ancient world, however, this was far from the case and it is estimated that a child had only a fifty percent chance of reaching its tenth birthday. Perhaps because of this, Roman attitudes to infants can seem callous. The author Pliny, for example, commented in his *Natural History* that there was a common belief that children did not possess souls until they were teething.

In contrast with adult burials, infant burials could take place within the town walls (see 6.9). Excavations in Lincoln have revealed over a dozen infant burials, both within and outside the walls, the majority being stillborn or dying very soon after birth. Interestingly, many were buried under the eaves or floors of buildings, particularly of

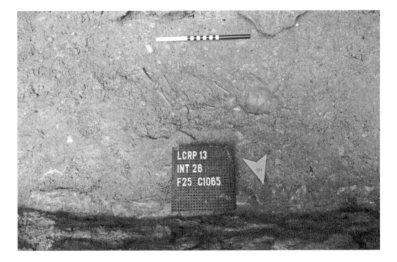

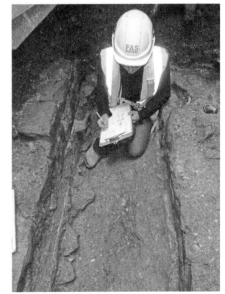

An infant burial excavated at Lincoln Castle in 2013. Found in a drainage gully between two buildings, the burial, while simple, was nevertheless respectful. The baby was either stillborn or died shortly after birth, and may have had scurvy. (FAS Heritage)

traders' houses, and it is possible that they were votive burials, protecting the family and business. Both Pliny and Juvenal refer to the practice of burying stillborns under eaves rather than cremating them. Infant burials have also been discovered at shrines, placed deliberately in pits as offerings.

6.9 Communal burials and burial clubs

The scale and grandeur of funeral monuments depended on the individual's wealth and status. Although Roman tombstones can be seen in museums across Britain, we should not forget that they represent a tiny proportion of the population and were a form of memorial unattainable for most people. In order to ensure a respectful burial, many people paid money into burial clubs, often organised by trade guilds. This would mean a communal burial – for example, in a *columbarium* (literally 'dovecot'), with other guild members.

Burials in the Roman world occurred outside of urban spaces, usually lining the major roads leading in and out of settlements. Graves of the rich and poor, both grand and communal, existed side by side, solemnly guarding the routes into the town. In Lincoln, cemeteries have been identified on all sides of the town, stretching up to 1 km away, and finds of small memorial plaques indicate the presence of at least one *columbarium*. Cemeteries have also been identified at towns such as Ancaster and Horncastle.

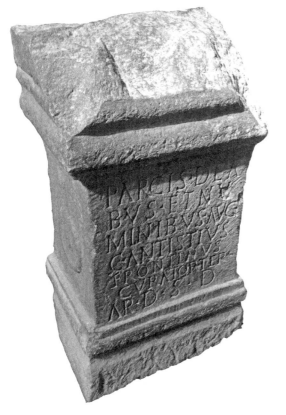

Altar discovered at St Swithin's church, Lincoln, in 1884. The inscription reads, '*PARCIS DEABVS ET NVMINIBVS AVG(VSTORVM) G(AIVS) ANTISTIVS FRONTINVS CVRATOR TER(TIVM) AR(AM) D(E) S(VO) D(EDICAVIT)*'. This translates as, 'To the Goddesses, the Fates and the Divinities of the Emperors, Gaius Antistius Frontinus, guild-treasurer for the third time, dedicated this altar at his own expense.' Sadly we do not know what guild this refers to, but as treasurer Frontinus likely dealt with members' burial-club donations. (Author)

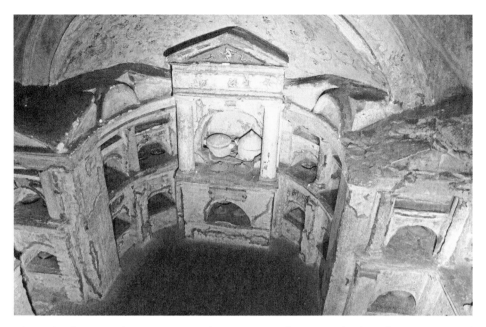

The *columbarium* of Pomponius Hylas in Rome, dating to the late first century and containing the remains of a single extended family. Guild *columbaria* would have looked very similar. (Matthew Berry)

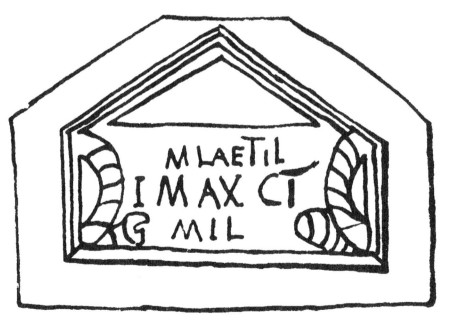

This stone plaque, discovered in 1776 and now lost, was placed in a *columbarium* to mark the remains of a soldier named Marcus Laetilius Maximus. He may have died on active service at Lincoln or have been a veteran, but was likely to have been buried alongside other soldiers. The unit he belonged to may have been recorded on the outside of the tomb. (Reproduced by permission of the Administrators of the Haverfield Bequest)

7

Trade and Industry

7.1 Stone quarrying and carving

The limestone escarpment that runs north-south through western Lincolnshire has been a source of building stone for millennia, used in Roman buildings just as it was to construct Lincoln's magnificent cathedral. The limestone was also suitable for sculptural work, and is the stone used in virtually all of the Roman carvings known from the county. The major quarries seem to have been the Greetwell quarries (to the east of Lincoln) and Ancaster, but the self-destructive nature of quarrying makes accurately identifying ancient extraction sites difficult. What is certain is that the quarries would have been well organised and important industrial sites, perhaps even under imperial control.

Stonemasons would doubtless have spent the majority of their time fashioning ashlar blocks for buildings, but specialists would have provided inscriptions and decorative and figurative carvings for official projects and private commissions. The demand for the stone was widespread, as evidenced by the fact that the wealthy London 'Spitalfields woman' was buried inside a Lincolnshire limestone sarcophagus.

Carving from Lincoln of a young boy holding the reins of a chariot. It may have been part of a tombstone, although it has also been suggested that it was from a frieze, perhaps representing the youth of the town. (The Collection)

56

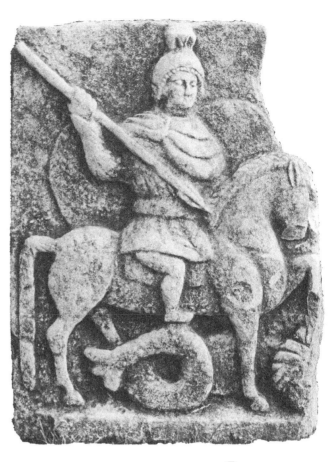

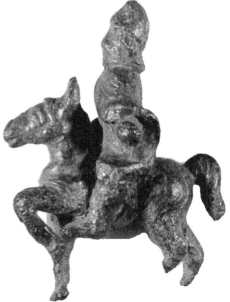

This enigmatic carving was discovered at Stragglethorpe in 1977. It depicts a cavalryman spearing a snake-like creature beneath his horse, although the figure is likely to be a deity rather than a mortal soldier. It may represent Mars and relate to bronze figurines of him on horseback, finds of which centre on Northamptonshire but are also found in Lincolnshire. (The Collection and Portable Antiquities Scheme)

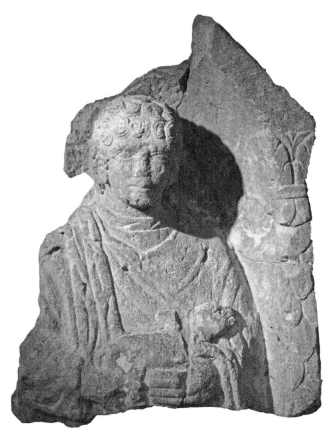

The inscription identifying the young man on this tombstone is sadly lost, and the carving of him holding a hare in his arms is all that remains of his monument, discovered during the construction of St Swithin's church in Lincoln in 1884. (The Collection)

7.2 Salt production and trade

Salt was a valuable commodity in the ancient world and the fenlands of Lincolnshire and East Anglia were important salt-production landscapes, exploited from the Bronze Age onwards. Methods of salt production remained broadly constant, with sea water channelled into pools, allowed to concentrate, and then evaporated over fires in ceramic 'pans'. The salt could then be traded locally, regionally and even nationally, and used primarily in food preservation but also in other industries such as leather tanning and cheese making.

The archaeology of the fenland is complicated and evidence of salt making fragmentary and often deeply buried. Consequently our understanding of the organisation of the Roman salt industry is incomplete. Were individual salterns operated as cottage industries or as part of wider workshops? Was the entire industry (and its profits) controlled directly by the provincial government? Most evidence of production is from the first and second centuries. Did landscape or economic changes lead to the decline of the industry in the later Roman period or have later salterns simply not yet been uncovered in the deeper silts? The geographer Ptolemy refers in the second century to a place in the fens called *Salinae*, but its precise location is uncertain. Does he refer to a specific settlement or make a more general reference to the key industry of the area?

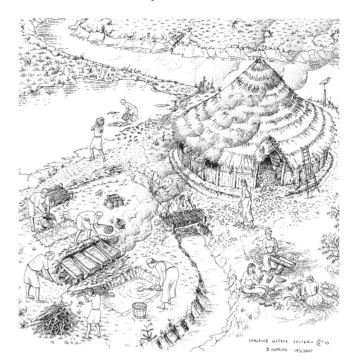

Reconstruction by Dave Hopkins of the first-century saltern at Wygate, Spalding. (Heritage Trust of Lincolnshire)

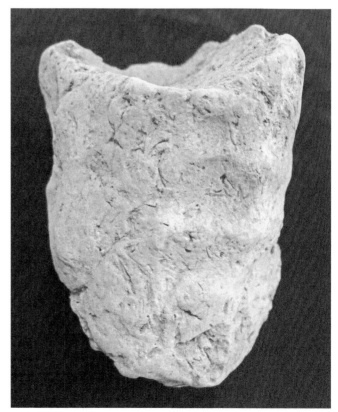

A support for an evaporating pan, created by simply squeezing a lump of clay into shape. The maker's fingerprints can still be seen. (The Collection)

7.3 Ceramic production and trade

The ubiquity of Roman pottery belies its complexity. Almost every arable field in Lincolnshire contains at least some, yet its manufacture, chronology and distribution are among the most complicated and significant areas of Romano-British study. From dull grey cooking pots to glossy red imported samian, drinking beakers from the Nene Valley and specialist vessels such as *amphorae* (see 3.7), *mortaria* and roof tiles – the evidence provided by ceramics is crucial to our understanding of both the function and dating of archaeological sites.

Lincolnshire has produced evidence of various pottery kilns, often producing specific wares suited to the local clays which were traded both locally and further afield. Around Lincoln, for example, kilns at the 'Technical College' (Now Lincoln College on Monks Road) and South Carlton produced *mortaria*, which during the second century were being used by the army on Hadrian's Wall. At the Racecourse, Rookery Lane and Swanpool kilns, functional grey cooking vessels were being produced that served the kitchens of homes across Lincolnshire. Alongside local products, vessels from other parts of Britain such as the Nene Valley and Yorkshire joined those from further afield, such as Gaul and Germany, on the tables of wealthier citizens.

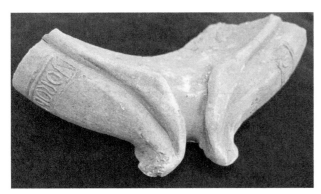

Rim and spout of a *mortarium* (mixing bowl), made at the South Carlton kilns by the potter '*VOROLAS*'. (The Collection)

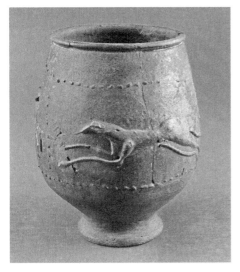

Drinking beaker depicting hounds chasing a hare, made in the Nene Valley, Northamptonshire, and found at Eastgate, Lincoln, in 1884. (The Collection)

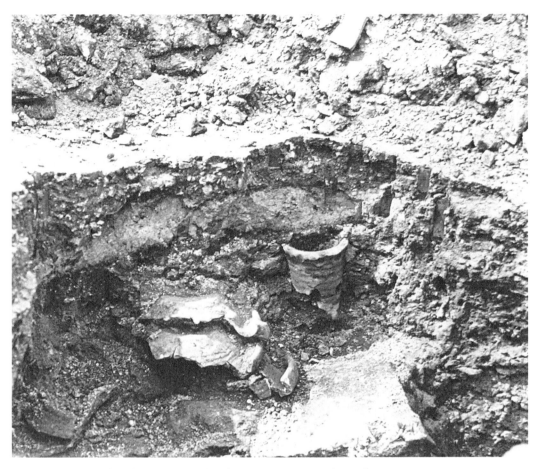

The Technical College pottery kilns during excavation. (The Collection)

8

Everyday Life and Leisure

8.1 Jewellery, fashion and identity

The wearing of jewellery may seem a simple matter of fashion and taste, but strong cultural messages can be portrayed, deliberately or subconsciously, through the wearing of different types and styles of jewellery, in certain materials and combinations. In Roman Lincolnshire, for example, the decision to wear imported gold earrings rather than a more locally made brooch or bracelet may have made a strong statement about social and cultural aspirations, and the level to which someone had adopted Roman fashions. Items such as brooches had a primarily practical purpose, but also made a statement about the wearer to other people.

Jewellery finds are valuable to archaeologists as styles changed regularly, providing dating evidence for sites and clues to cultural identity and trade networks. Certain types and styles of jewellery were associated with particular societal groups (such as the military), were popular as religious offerings, or were perceived as having healing or protective properties (see 6.6 and 8.2); their study can tell us more than simply what was fashionable.

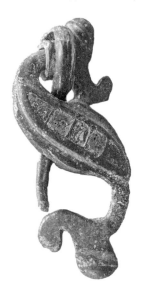

Enamelled dragonesque brooch from Osbournby, dating to *c.* AD 50–150. Dragonesque brooches only appeared after the Roman invasion, but their style and decoration is distinctly British. British enamelled brooches are found across the empire, suggesting that they were seen as exotic and valued items in other provinces. (Portable Antiquities Scheme)

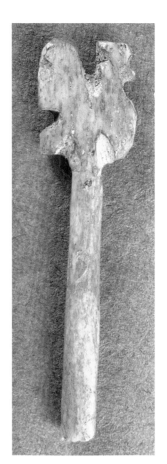

Bone hairpin from Lincoln, decorated with a cockerel. The cockerel was a symbol of Mercury, protector of travellers and merchants. Was this hairpin simply a functional item decorated with an animal design, or valued as a portable religious object? (The Collection)

A simple gold earring with green glass setting, found at Wickenby. (Portable Antiquities Scheme)

8.2 Specialist jewellery

This brooch, in the form of a seated greyhound, is one of a small number of realistic depictions of such dogs known on jewellery. The majority of dogs appearing on Roman brooches are highly stylised, whereas the craftsman responsible for this piece has attempted to capture the gracile form and alertness of the specific breed. Britain was known in the ancient world for dog breeding, with classical authors such as Strabo and Tacitus commenting that hunting dogs were important exports from the island. A brooch like this may have been commissioned by such a breeder to highlight their particular association with these dogs.

An interesting and perhaps surprising facet of dogs in Roman Britain is their connection with healing. The temple complex at Lydney Park in Gloucestershire was

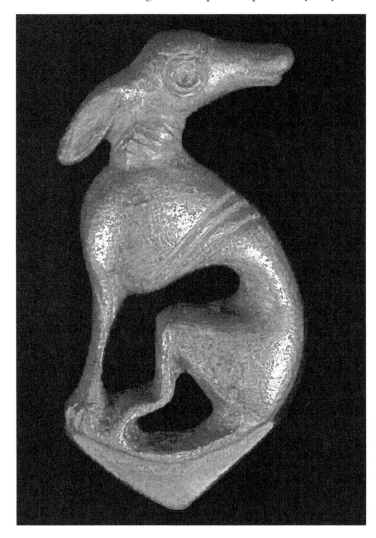

Tinned copper-alloy brooch in the form of a greyhound, found at Fulbeck. (The Collection)

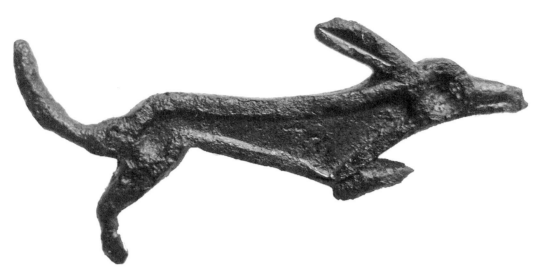

A stylised zoomorphic brooch in the form of a running hound, found near Sleaford. (Portable Antiquities Scheme)

a healing centre presided over by the god Nodens, and small statuettes of dogs have been discovered there. Live dogs may have had a role to play in the healing process, and brooches such as this might also be interpreted as having a healing or protective function.

8.3 Public bathing

The concept of communal bathing is alien to our modern sensibilities, but in the ancient world, where private washing facilities were virtually non-existent, it was a fact of life. Public bathing went beyond the simple act of cleansing the body, however, and became a cultural symbol of Rome, exported to its provinces as a symbol of 'civilised' life. Public baths were places of relaxation, business and socialising as much as they were about scrubbing and scraping.

Roman Lincoln had at least one public baths, located just inside the northern walls of the upper *Colonia*, near the point where the aqueduct entered (see 9.2), but may have had others. The Lincoln public baths were excavated in 1957, although further excavation and analysis is required to understand their layout and development fully. Wealthier private dwellings, particularly in the later Roman period, often had private bath suites and some rural villas, such as Denton, Scampton and Winterton, had elaborate bathing facilities.

> Your face, which is beautiful, you cover with a black veil; but with your person, which is not beautiful, you offend the waters in which you bathe. Imagine that the nymph of the brook herself addresses you in these words of mine: 'Either uncover your face, or bathe dressed'. (Martial, epigram 3.3)

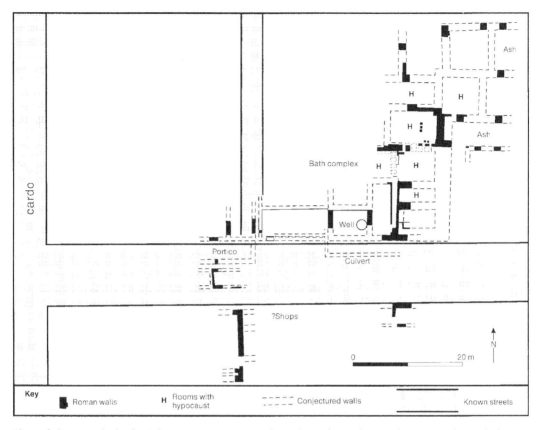

Plan of the Lincoln baths. The entrance seems to have been from the south, via a colonnaded façade from the main street. The baths were extended at least twice, most likely in the second and third centuries. (Historic England/City of Lincoln Council)

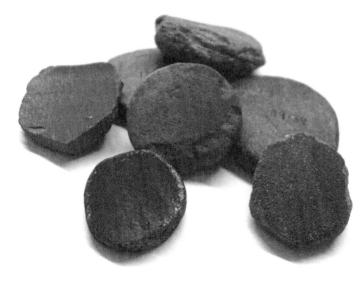

These simple ceramic gaming counters from the Lincoln baths demonstrate that it was a place to while away an afternoon in leisure, playing and chatting with friends. (The Collection)

Marble inlays from the walls of the Lincoln baths reveal that some rooms were expensively decorated. Baths were important social structures and the town's magistrates would have been keen to ensure that it made a good impression to visitors. (The Collection)

8.4 Chariot racing

Despite our enduring disgust and fascination with gladiatorial combat and the place it occupies in modern perceptions of Roman culture, chariot racing was the more popular spectator sport in the Roman world. The *Circus Maximus* at Rome held an incredible 250,000 spectators (according to Pliny), compared with the more modest 50,000 of the Colosseum. The popularity of the sport in Britain is harder to gauge, however. Horses were important animals in native British culture, and the Britons were famed for their skills with chariots in battle. Horse-related sports and competitions must have been prevalent yet only one classically styled circus has been identified in Britain, at Colchester.

Depictions of chariot racing have been found in Lincolnshire. A panel from a mosaic at the fourth-century villa at Horkstow, discovered in 1797, is the best known and depicts the drama and excitement of a race in progress. Images of charioteers are known from Lincoln in the form of a stone carving of a young boy (see 7.1) and from Tallington in the form of a bronze statuette. Do they indicate that chariot racing took place in Lincolnshire or were they simply standardised classical images adopted by people aping popular Roman culture?

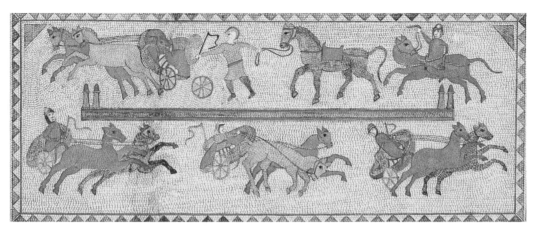

Panel from the Horkstow mosaic pavement, depicting a chariot race. Illustrated by William Fowler of Winterton. (The Collection)

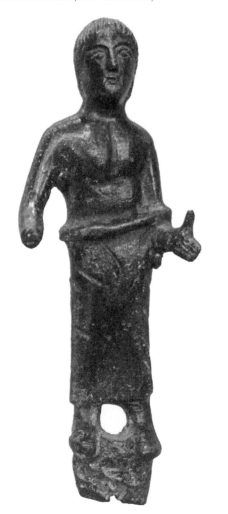

Bronze statuette of a charioteer, discovered at Tallington in 1948. Stripped to the waist and holding his hands out to take the reins, the function of this statuette is unclear but it was originally part of a larger object. (The Collection)

8.5 Organic artefacts

Organic materials rarely survive in British archaeology, and there are many wooden, leather and textile products of which we have little understanding, yet which must have been important everyday items. Thankfully organic remains do survive in certain conditions and excavations around the Roman waterfront in Lincoln in the 1980s have added much to our evidence of life in the town, despite many items being found in rubbish dumps used to reinforce the edge of the waterfront rather than in their primary contexts.

Over seventy shoes were discovered, demonstrating differing styles and fashions, some with delicate openwork decoration and iron hobnails. Offcuts from leather working indicate that these and other products were made locally. Other, more unusual, organic items include a wooden scoop, which would not look out of place in a modern dried-food store and a handled 'paddle' pierced with regular holes, but which is of unknown function. Was it used for getting bread out of an oven? At St Mark's, close to the traders' houses (see 3.5), a wooden ladder was discovered. Perhaps most fascinatingly, Lincoln's Roman waterfront has produced the earliest known evidence of cockroach in Britain, demonstrating the daily pests with which residents had to contend.

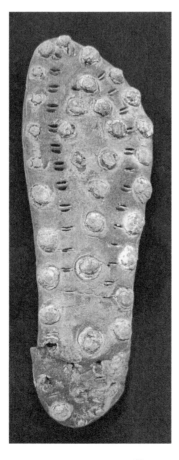
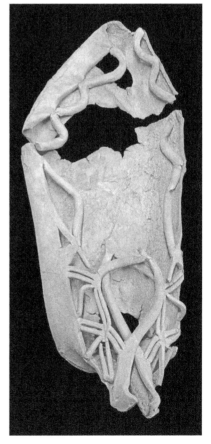

Leather shoe with iron hobnails on the sole, probably made for a woman, and a sandal with decorative leatherwork. (The Collection)

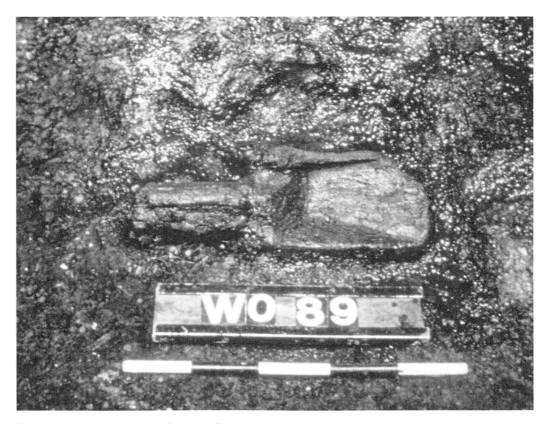

Wooden scoop. (City of Lincoln Council)

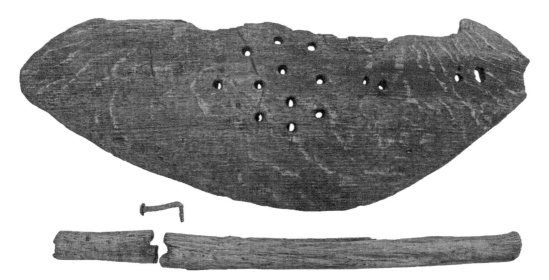

Wooden 'paddle'. (The Collection)

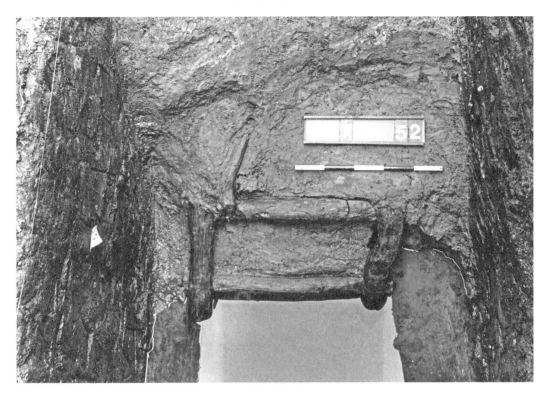

Wooden ladder. (City of Lincoln Council)

9

Roads, Waterways and Infrastructure

9.1 The road network

The road network is one of the most famous of Rome's legacies. 'All roads lead to Rome', as the saying goes. While that isn't strictly true, the establishment of a good road network was a major factor in Rome's military and economic success, although we should not assume that formalised roads did not previously exist. The road network enabled people, goods and information to travel with increased efficiency, and the imperial bureaucracy relied on a system of *'mansios'*, inns where travelling officials could change horses and be assured of good accommodation at regular intervals along major routes. Many settlements sprang up to support and benefit from such systems.

As part of the management of the road network, milestones were set up every Roman mile to mark the distance to nearby settlements. One milestone was placed in a prominent position outside Lincoln's forum, set up under the breakaway Gallic Emperor Victorinus (reigned AD 269–271). It was doubtless part of a publicity campaign, as the inscription replaced an earlier text that was chiselled away and prominently displayed Victorinus's assumed imperial titles. It records the distance from *Lindum* to *Segelocum* (Littleborough on Trent).

The Roman road at Tillbridge Lane, near the site of the Scampton villa. The road runs to the River Trent, where it could be crossed at Littleborough on Trent. (Author)

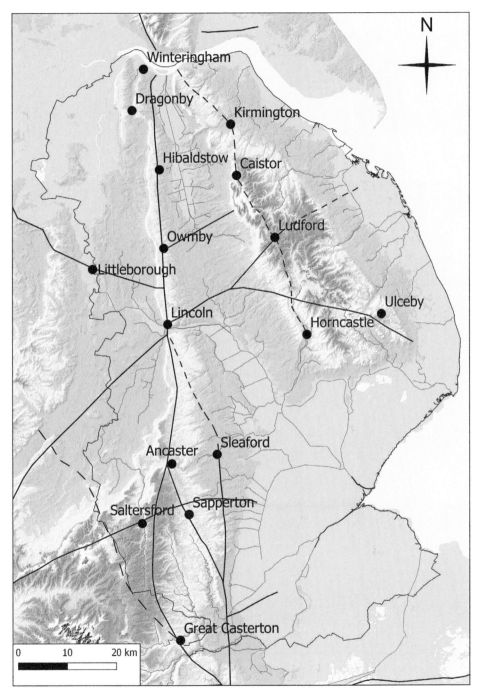

The major Roman roads of Lincolnshire. (Dr Adam Daubney. Contains OS data © Crown Copyright and Land-Form Panorama data (2016))

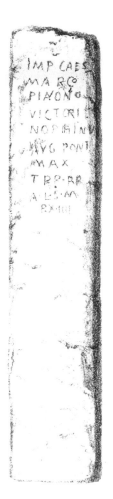

Left: Milestone from Bailgate, Lincoln. The inscription reads, '*IMP(ERATORI) CAES(ARI) MARCO PIAVONIO VICTORINO P(IO) F(ELICI) INV(ICTO) AVG(VSTO) PON(TIFICI) MAX(IMO) TR(IBVNICIAE) P(OTESTATIS) P(ARTI) P(ATRIAE) A L(INDO) S(EGELOCVM) M(ILIA) P(ASSVM) XIIII*'. This translates as, 'For the Emperor Caesar Marcus Piavonius Victorinus Pius Felix Invictus Augustus, Pontifex Maximus, with Tribunician power, father of his country, from Lindum to Segelocum fourteen miles'. (The Collection)

Below: Radiate of the Gallic Emperor Victorinus, found at Spridlington. (Portable Antiquities Scheme)

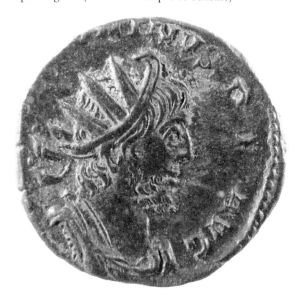

9.2 The Lincoln aqueduct

The function of the aqueduct that served Lincoln is one of *Colonia's* most fascinating archaeological mysteries. The concrete-jacketed ceramic pipe, running into north-eastern Lincoln along the line of the modern Nettleham Road, has been known for centuries but, despite twentieth-century excavations, questions over how, and even if, it operated still remain. The line of the aqueduct is well evidenced as far as the Roaring Meg spring, which lies approximately 2 km north-east of Lincoln, but around 20 m lower. If the Roaring Meg were the source, a system to lift or pump the water would be required, but no structures to facilitate such a task have yet been discovered. Another theory is that the aqueduct operated using an inverted siphon to bring the water from higher ground. To achieve this, the source would have to be around 25 km away in the Lincolnshire Wolds, and no evidence of the aqueduct has been found beyond the Roaring Meg. The aqueduct therefore remains enigmatic and, although further excavation may provide the answer, it is possible that it was an ambitious but failed engineering experiment.

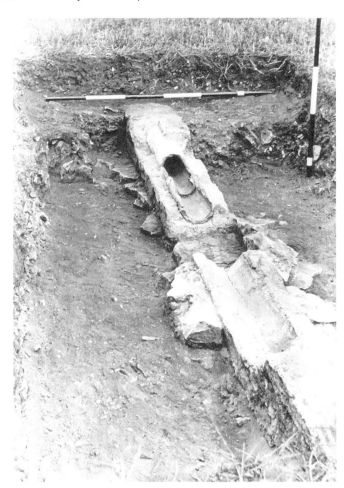

The aqueduct pipe during excavations along Nettleham Road in 1973. (The Collection)

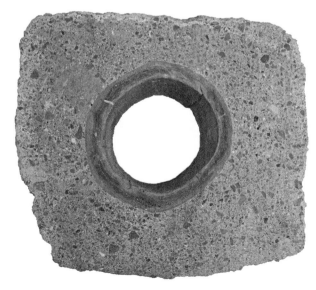

Section through the aqueduct showing the ceramic pipe contained within its jacket of *opus signinum*, a form of Roman concrete. (The Collection)

9.3 Lincoln's public fountain

Roman towns were carefully planned, with key buildings located according to broadly predetermined patterns. The street grid was an essential element of this planning, and major thoroughfares through the town were home to important public buildings. This was to ensure that they were easy to find, and that the prestige of the town was prominently displayed to visitors and to enable wealthier citizens and magistrates to process publically between business, religious and entertainment venues.

In 1830, the base of an octagonal fountain was discovered at St Peter at Arches, just inside the southern gate of the lower *Colonia*. Most likely set inside its own courtyard, the fountain seems to have been public rather than belonging to a private property. Such a public amenity was rare in the western empire, particularly so in Britain, and must be viewed as a prestigious feature of the town, immediately noticeable to those arriving through the gateway. The construction date of the fountain, excavated in 1953, is unknown but it was operating in the third century and fed by piped water. Other remains nearby include a probable temple to Mercury, a colonnade and possibly a bathhouse, which combine to suggest that the area was one of some pretention.

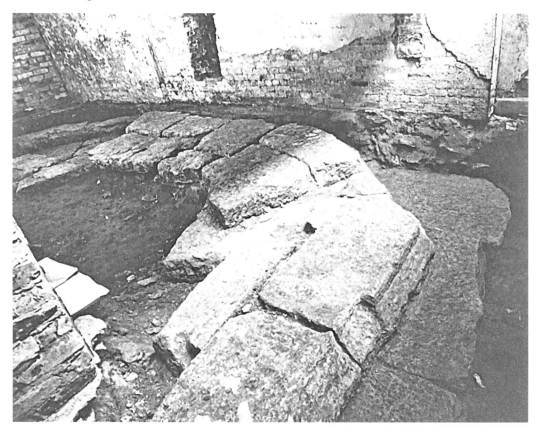

The fountain being excavated in 1953. (The Collection)

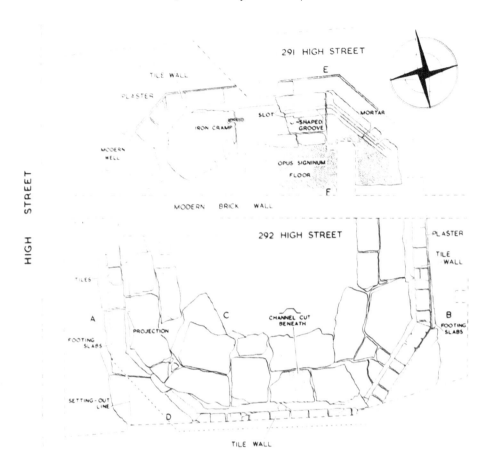

Plan of the base of the fountain. (The Collection)

9.4 The Car Dyke

The Car Dyke is an 85-mile-long artificial waterway that runs southwards through Lincolnshire, travelling along the western edge of the fens from the River Witham just east of Lincoln to Peterborough. Roman settlements are scattered along both sides of it, and it is believed that it was dug in the AD 120s as part of a scheme to drain the fenland for habitation and agriculture. This date puts the work in the reign of the Emperor Hadrian (AD 117–138), and it is possible that he initiated or endorsed such a scheme personally as he travelled through Britain. The largest known Romano-British canal, the Car Dyke is believed to have been around 15 m wide and around 2–4 m deep, making its construction a substantial engineering project.

The question of whether the Car Dyke was purely for drainage or could have been used for transportation has been much debated. Although some sharp turns in its route would make navigating its complete length difficult, it is possible that shorter sections may have been used for more local trade and transport.

The Car Dyke at Branston Booths. (Author)

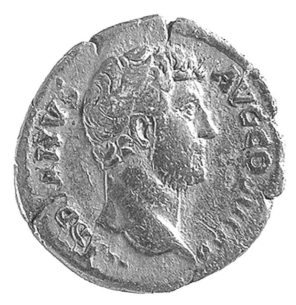

Denarius of the Emperor Hadrian found at Market Rasen. (Portable Antiquities Scheme)

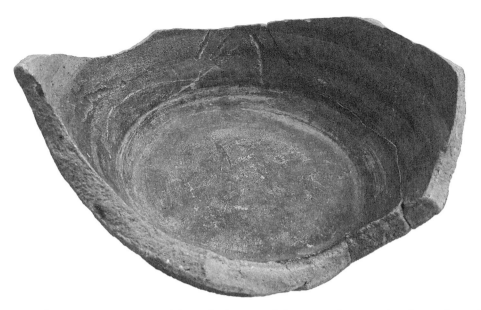

Base of a Roman pot excavated from the bottom of the Car Dyke at Washingborough in 1971. Even simple objects such as this can provide crucial dating evidence when found in context. (The Collection)

10

Politics and Social Status

10.1 Local government

Roman town administration relied upon a system of local aristocrats and businessmen taking up political positions alongside their other interests, enhancing their own prestige and wealth while serving their local community. The *Ordo*, the town council, traditionally comprised 100 of these local dignitaries (*decurions*), who would be responsible for maintaining and enhancing the town's facilities, managing public contracts, and organising religious festivals and entertainments. They also oversaw the collection of taxation and, through a careful balance of these responsibilities, would hope to simultaneously enhance their local standing and their wealth.

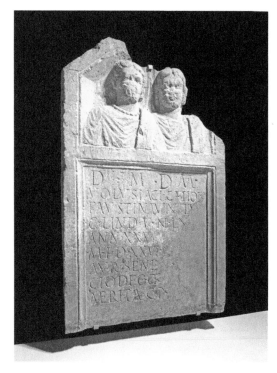

Tombstone of Volusia Faustina and Claudia Catiotua. The inscription for Volusia reads, '*D(IS) M(ANIBVS) VOLVSIA FAVSTINA C(IVIS) LIND(ENSIS) V(IXIT) ANN(OS) XXVI M(ENSEM) I D(IES) XXVI AVR(ELIVS) SENECIO DEC(VRIO) OB MERITA C(ONIVGI) P(OSVIT)*'. This translates as, 'To the spirits of the departed and to Volusia Faustina, a citizen of Lindum, lived twenty-six years, one month, twenty-six days. Aurelius Senecio, a councillor, set this up to his well-deserving wife'. The partial inscription for Claudia simply states that, 'Claudia Catiotua lived sixty (or more) years'. (Trustees of the British Museum)

One of Lincoln's *decurions* is known because of the tombstone he set up to his wife. Volusia Faustina died in the mid-third century, and Aurelius Senecio dutifully mourned her passing with an expensive tombstone, complete with a portrait of her. Unusually, however, the tombstone also features a second female, Claudia Catiotua, who was at least sixty when she died and was added to the tombstone later. Was Claudia a relative? A second wife of Senecio? A favoured elderly slave? The relationship between the three sadly remains a mystery.

10.2 A freed imperial slave in Lincoln

Slavery was universal in the ancient world (even in Iron Age Britain) and a cornerstone of the Roman economy. Although we only have fleeting glimpses of its presence in Roman Lincolnshire, we can assume that slaves played a role in both urban and rural life. Slavery took many forms, and it is difficult to reconcile the difference between the well-educated Greek slave who taught rhetoric to wealthy Roman children on the bay of Naples with the Celt forced to live a short and brutal life in a Spanish mine. Although to our minds slavery of any kind is abhorrent, to the Romans it was a fact of life and a reflection of a natural order. What is most surprising about Roman slavery, however, is that freed slaves could become prominent and successful members of society. For example, it is estimated that at the time of the eruption in AD 79 over half of the population of Herculaneum were freed slaves or their descendants.

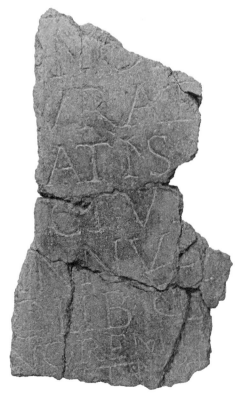

Fragmentary inscription referring to a 'freedman of the emperor(s)' who 'rebuilt the temple on account of his appointment to the sevirate' (priesthood of the Imperial Cult (see 6.2)). The inscription was re-used in the foundations of the church at St Paul in the Bail, lending weight to the suggestion that the temple to the Imperial Cult (see 3.2) lay nearby, perhaps adjoined to the south of the forum. (The Collection)

An inscription from Lincoln commemorates a former imperial slave restoring a temple, indicating that he has gone on to possess wealth and influence since gaining manumission. Slaves owned directly by the emperor could have had various duties, and this slave may have worked for the provincial administration, managing imperial estates and resources before buying his release or being freed for long and loyal service.

10.3 Slavery and the British slave trade

This emotive copper-alloy figurine depicts a human figure, hunched up with hands, feet and neck bound. The figure is probably male and appears to be naked. It belongs to a small but iconographically consistent group of such figures known from Britain and Germany and believed to date to the second and third centuries. The function of the figures is unknown, but the perforation through the centre and the angle of the legs suggests they were attached to larger objects, perhaps even as decorative fittings, though distasteful ones to our eyes. That these figures represent captured enemies or slaves seems certain. Whatever their function and the ethnicity they depict, the pathetic human misery represented is clear.

The great military expansions of the Roman Empire had mostly come to an end by the second century, and there was a corresponding fall in slaves coming onto the market

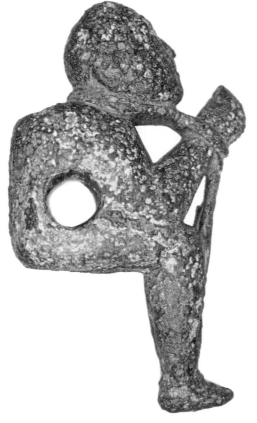

Bound captive figurine from Broxholme.
(Portable Antiquities Scheme)

from defeated enemies. Internal rebellions may have replaced external sources to meet Rome's insatiable demand for slaves and Britain certainly had its own slave markets. A writing tablet from London dated *c*. AD 75–125 records the sale of a female slave, ironically named 'Fortunata', and slaves appear on curse tablets from Bath.

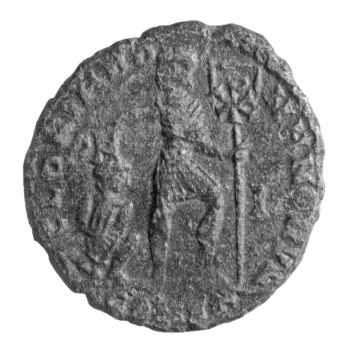

Images of defeated enemies often appear on Roman coinage. Here, the Emperor Valens (AD 364–378) drags a tiny captive by the hair and two dejected prisoners sit bound beneath a Roman military standard on a nummus of Constantine I (AD 307–337). Found at Ancaster and Lusby with Winceby. (Portable Antiquities Scheme)

10.4 Literacy

Levels of literacy in the ancient world, especially in outlying provinces such as Britain, are difficult to ascertain. The great works of poetry and prose produced in classical Italy do not mean that the average subsistence farmer in rural Lincolnshire was even able to write his own name; yet there is evidence to suggest that a basic level of literacy may have been widespread, particularly in towns. Certainly anyone involved in the Roman military or local governance would have been expected to have a command of Latin. Finds of wooden writing tablets and associated styli, inkwells and seal boxes attest to this official literacy, even if most finds sadly do not have traces of their original messages surviving, unlike the spectacular assemblages of tablets from Vindolanda and London.

Ceramic sherds sometimes provide evidence of everyday literacy, having names and slogans scratched onto their surfaces. Personal names make up the majority of legible graffiti and, as drinking beakers make up a large proportion of vessels inscribed in this way, it seems that they represent drinkers claiming ownership of their favourite cup.

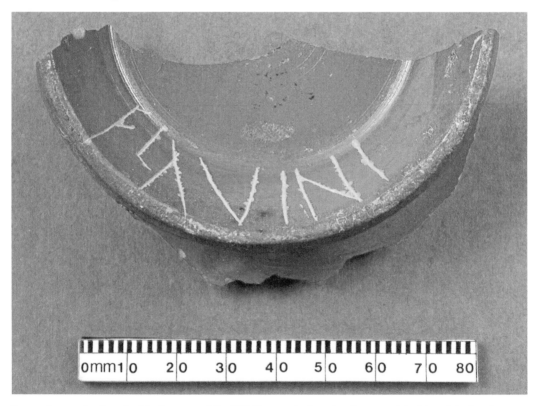

Base of a samian bowl with the name '*FLAVINI*' scratched on it, discovered in Lincoln's Castle Hill in 1957 in association with a hoard of eleven bronze coins dating to the reigns of Claudius (AD 41–54) to Vespasian (AD 69–79). As the sherd also dates to the late first century, it seems that it was placed to identify the owner of the small hoard, perhaps a soldier during the final years of the life of the fortress. (The Collection)

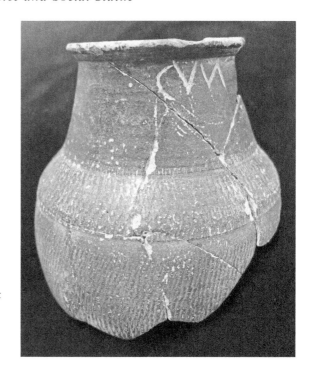

Drinking beaker, excavated south-east
of Brayford Pool in Lincoln.
The abbreviated name 'CVN'
has been scratched near the rim.
(The Collection)

Part of a wooden writing tablet
excavated along the north bank of the
waterfront at Lincoln (see 8.5). This
is the only writing tablet currently
known from Lincolnshire, although
numerous examples of writing
equipment such as styli and seal boxes
have been found across the county.
(The Collection)

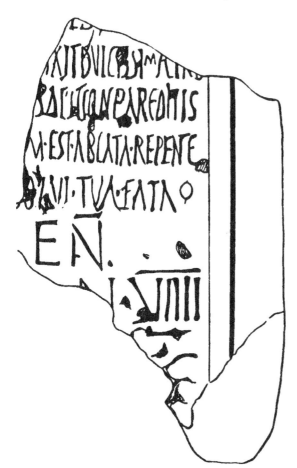

Fragment of a tombstone from Lincoln to an unknown girl who died aged nine. The inscription refers to her parents lamenting at her being 'torn away no less suddenly than the partner of *Dis*'. This reference to the myth of the 'rape of Proserpina', who was abducted to the underworld by the god *Dis* (Hades), attests to a level of classical education and literacy. (Reproduced with permission of the administrators of the Haverfield Bequest)

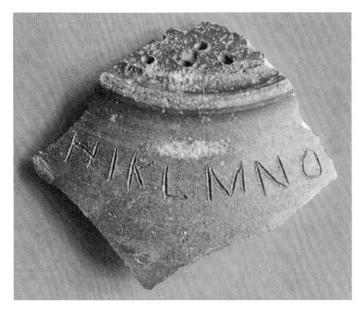

Sherd from Sleaford with part of an alphabet ('H I K L M N O') scratched on to it. Note the lack of the letter 'J' in the Latin alphabet. (Old Sleaford Heritage Group)

10.5 Claudia Crysis, a Roman matriarch?

Life expectancy in the ancient world varied depending on social status and cultural background. The infant mortality rate was extremely high (see 6.8) but, if a person survived beyond those perilous early years, they might expect to live for another forty or more, unless involved in a particularly dangerous industry or a slave forced to spend a miserable existence stoking the fires of a bathhouse. Individuals living a more comfortable life might expect to survive into their sixties or seventies, and some attained great age, such as Sextus Turannius, who threatened to starve himself to death at the age of ninety after being told to retire from public office by the Emperor Caligula. In Roman Britain, tombstone and skeletal evidence suggests that the average person died before reaching fifty, with women living around a decade less than men.

The tombstone of Claudia Crysis, discovered on Lindum Road in Lincoln in 1830, is therefore remarkable, as its simple dedication records that Claudia lived to be ninety years old, making her the oldest known woman from Roman Britain. Can we perhaps imagine her as a matriarchal figure, recognised throughout the town and of some social standing to have lived such a long life? In a time without birth records, however, who could corroborate her actual age?

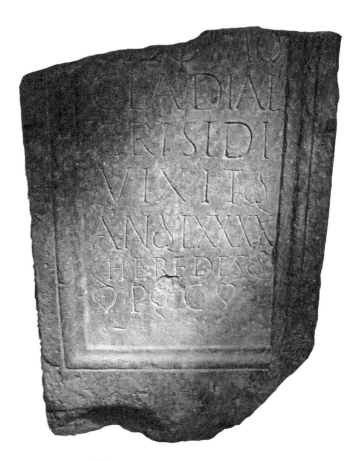

Tombstone of Claudia Crysis. The inscription reads, '*D(IS) M(ANIBVS) CLAVDIAE CRYSIDI VIXIT AN(NOS) LXXXX HEREDES P(ONENDVM) C(VRAVERVNT)*', which translates as, 'To the spirits of the departed and to Claudia Crysis, who lived ninety years. Her heirs had this (tombstone) set up.' (The Collection)

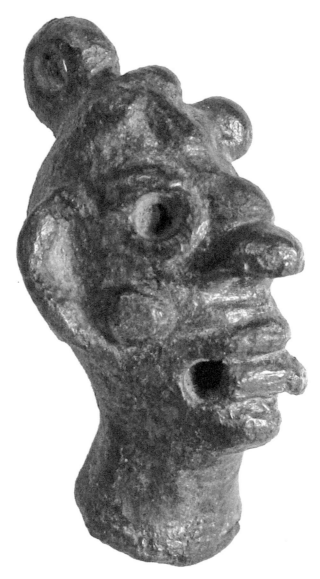

Social attitudes to the elderly and disabled in Roman Britain are difficult to ascertain. This bronze weight, found at Osbournby, depicts a grotesque head and may be a 'humorous' representation of disability, something often found on the Roman continent. (Portable Antiquities Scheme)

11

Late Roman Lincolnshire

11.1 A lost provincial palace?

Britain did not remain a single province of the Roman Empire. In the early third century it was divided into two parts (the north, *Britannica Inferior* (including Lincolnshire) and the south, *Britannica Superior*), and then again into four parts in the early fourth century. This fourth century re-organisation is believed to have seen Lincoln made a provincial capital, although the boundaries and even what names were given to which provinces

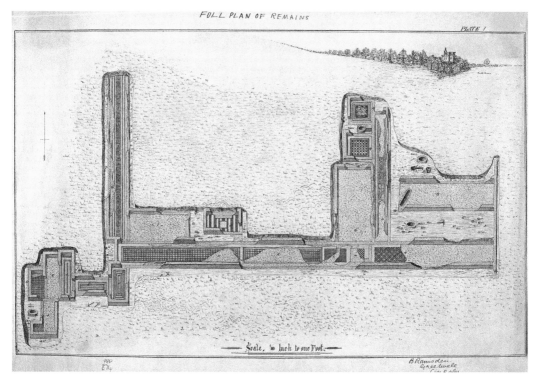

Mr Ramsden's illustration of the Greetwell villa remains. The complete structure would doubtless have extended further and had more rooms accessed via the long corridors. (The Collection)

Detail of a corridor mosaic with panels of geometric designs, *canthari* (urns), knots and flowers within guilloche borders. (The Collection)

are unclear. Lincoln may have been the capital of either *Flavia Caesariensis* or *Britannia Secunda*, and governed an area around the modern midlands and northern East Anglia.

In 1884 quarrying works at the eastern edge of modern Lincoln uncovered a late Roman residence of palatial scale and decoration. Regretfully the quarrying work destroyed the structure, but the manager Mr Ramsden recorded some of the discoveries, leaving us a glimpse of what once existed. The residence, now known as 'Greetwell villa', was on an enormous scale, possessing, if the drawings are accurate, the longest corridor known from any villa in Roman Britain. Was this grand structure the residence of the provincial governor?

11.2 The late Roman army

The Roman army of the fourth century was very different to that of the first century (see 2.2). Rome's expansion had ceased in the second century and a new military organisation was required. Military command was separated from provincial administration, and forces divided into two main types. The *limitanei* were permanently stationed at the empire's frontiers and the *comitatenses* were field armies. Substantial numbers of allies (*foederati*) were used and the army relied on conscription rather than the voluntary service of earlier centuries.

The extent of military presence in late Roman Lincolnshire is debated. The fourth century was a time of uncertainty and perceived threat, as evidenced by the strengthening of town walls at Lincoln, Ancaster and Great Casterton. The east and south coasts of late Roman Britain were defended by 'shore forts', but none are known on the Lincolnshire coast (although a lost 'castle' off Skegness may be Roman). On the assumption that Lincolnshire would have been defended, it has been suggested that the late walled enclosures at Caistor (see 4.2) and Horncastle (see 4.5) were cavalry bases, able to respond swiftly to incursions. However, as little is known of structures inside the walls, this remains speculative.

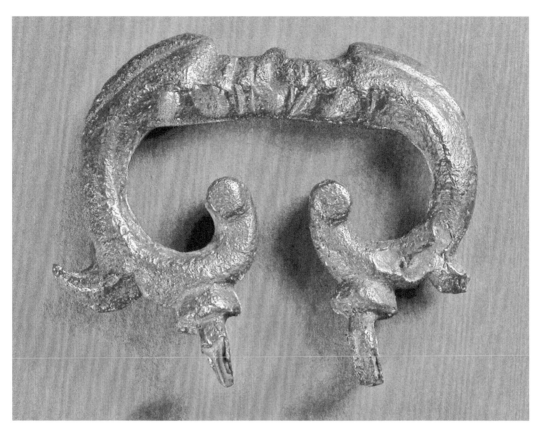

These belt buckles, found at Lincoln and Sleaford, are representative of a style believed to be Germanic in origin and worn by soldiers. Are they evidence of troops deployed to defend Lincolnshire, or simply that a paramilitary style of dress was fashionable or worn by civilian officials? (The Collection and the Portable Antiquities Scheme)

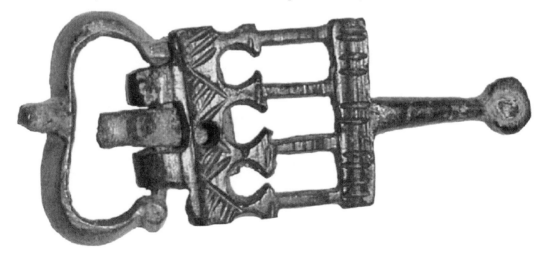

11.3 An early Christian church at Lincoln

The rise of Christianity from a small and sometimes persecuted cult in the Roman east to one of the world's dominant religions is a complex and fascinating subject. The late fourth century saw Christianity becoming Rome's official state religion under Theodosius I (AD 375–395), but Christian communities had been worshipping since the first century AD, and Tertullian informs us that they had been in Britain since the second century. The nature of late Roman Christianity is not fully understood. Ancient sources invariably reflect a Christian perspective and must be treated with caution. Much of the dogma of modern Christianity was still to be established and we can expect Romano-British Christianity perhaps to not have been viewed as an exclusive religious choice, and conversion linked to political aspirations as much as religious fervour.

Excavations at Lincoln's forum (see 3.2) revealed evidence of a series of apsidal structures, potentially beginning in the fourth century and adjoined to the interior colonnade of the forum. These have been interpreted as churches and attest not only to a Christian community in Lincoln, but one clearly connected to the governance of the town, located as it was in the heart of the administrative centre. A bishop from Lincoln named Adelphius is believed to have been one of four British clerics attending the Council of Arles in AD 314.

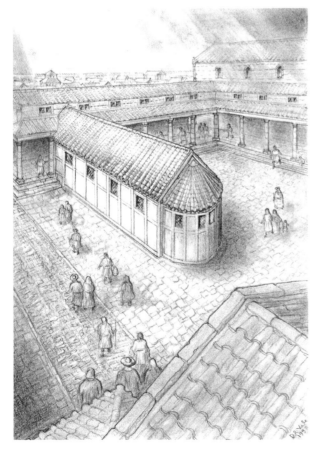

Reconstruction of the sixth-century church at St Paul in the Bail by David Vale. The fourth-century church on the same site may have been of a similar architectural style. (Society for Lincolnshire History and Archaeology)

11.4 Coinage and the end of Roman Lincolnshire

The traditional textbook date for the ending of Roman Britain – AD 410 – is a misleading one, which only reinforces misconceptions of hordes of Italians leaving these shores in a single and deliberate act of withdrawal. In reality, the means by which Britain ceased to be part of the Roman Empire was complex, and entwined with events across Europe. Political turmoil in the late fourth century had seen many soldiers withdrawn from Britain, often by usurpers challenging for power, but many Britons will still have considered themselves Roman long after AD 410. Some towns, including Lincoln, display evidence of the repair of public roads and amenities into the fifth century,

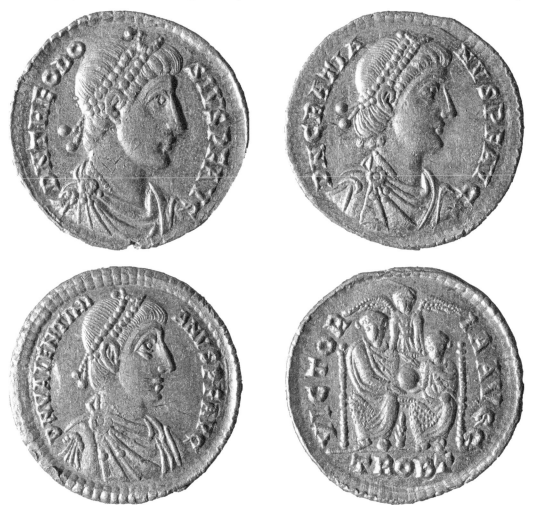

A hoard of three gold *solidi*, discovered north-east of Lincoln. Two coins, of Gratian and Theodosius I, date to AD 378–383 and the other, of Valentinian II, dates to AD 388–392. The coins were therefore probably lost or deposited in the AD 390s. All bear the same reverse image: two emperors sat with a globe between them, a winged Victory watching over their endeavours. (The Collection)

suggesting that local infrastructure continued to some extent, despite a breakdown in imperial and provincial governance.

The import of official coinage is one indicator of Britain's relationship with the rest of the empire. The value of the study of coin hoards and site finds lies in both the inherent chronology and dating provided by coinage, and in the implications for the state of local and national economies. Coin hoarding was a common event in the late fourth century and it has been suggested that coin use began to fall in the fifth century, to be replaced by a bullion-based economy.

Select Bibliography and Further Reading

Allason-Jones, Lindsay (Ed.), *Artefacts in Roman Britain: Their Purpose and Use* (Cambridge, 2011).

Bewley, Robert H. (Ed.), *Lincolnshire's Archaeology from the Air* (Occasional Papers in Lincolnshire History and Archaeology 11. Society for Lincolnshire History and Archaeology, 1998).

Brown, A. E. (Ed.), *Roman Small Towns in Eastern England and Beyond* (Oxbow Monograph 52. Oxbow, 1995).

Burnham, Barry and Wacher, John, *The 'Small Towns' of Roman Britain* (Batsford, 1990).

Creighton, John, *Britannia: The Creation of a Roman Province* (Routledge, 2006).

Darling, Margaret and Precious, Barbara, *A Corpus of Roman Pottery from Lincoln* (Lincoln Archaeological Studies No 6. Oxbow, 2014).

Ferris, Iain, *Roman Britain through its Objects* (Amberley, 2012).

Fincham, Garrick, *Landscapes of Imperialism: Roman and Native Interaction in the East Anglian Fenland* (British Archaeological Reports British Series 338. Archaeopress, 2002).

Field, Naomi and Hurst, Henry, *Roman Horncastle* (Lincolnshire History and Archaeology Vol 18. Society for Lincolnshire History and Archaeology, 1983).

Henig, Martin, *Religion in Roman Britain* (Batsford, 1984).

Johns, Catherine, *The Jewellery of Roman Britain: Celtic and Classical Traditions* (UCL Press, 1996).

Jones, Michael, *Roman Lincoln: Conquest, Colony and Capital* (Tempus, 2002).

Fulford, Michael and Holbrook, Neil (Eds), *The Towns of Roman Britain: the Contribution of Commercial Archaeology Since 1990* (Britannia Monograph Series No 27. Society for the Promotion of Roman Studies, 2015).

Haarer, F. K. (Ed.), *AD 410: The History and Archaeology of Late and Post-Roman Britain* (Society for the Promotion of Roman Studies, 2014).

James, Simon and Millett, Martin, *Britons and Romans: Advancing an Archaeological Agenda* (CBA Research Report 125. Council for British Archaeology, 2001).

Lane, Tom and Morris, Elaine L. (Eds), *A Millennium of Saltmaking: Prehistoric and Romano-British Salt Production in the Fenland* (Lincolnshire Archaeology and Heritage Reports Series No 4. Heritage Trust of Lincolnshire, 2001).

Laurence, Ray, Esmonde Cleary, Simon and Sears, Gareth, *The City in the Roman West c. 250 BC–c. AD 250* (Cambridge, 2011).

Malone, Steve and Williams, Mark (Eds), *Rumours of Roman Finds: Recent work on Roman Lincolnshire* (Heritage Trust of Lincolnshire, 2010).

Mackreth, D. F., *Brooches in Late Iron Age and Roman Britain*. (Oxbow, 2011).

Mattingly, David, *An Imperial Possession: Britain in the Roman Empire* (Penguin, 2006).

McCarthy, Mike, *The Romano-British Peasant: Towards a Study of People, Landscapes and Work During the Roman Occupation of Britain* (Windgather Press, 2013).

Todd, Malcolm, *The Coritani (Peoples of Roman Britain)* (Duckworth, 1973).

Todd, Malcolm, *The Roman Town at Ancaster Lincolnshire: The Excavations of 1955–1971* (University of Nottingham/University of Exeter, 1981).

Palmer-Brown, Colin and Rylatt, Jim, *How Times Change: Navenby Unearthed* (Pre-Construct Archaeological Services Ltd Monograph No 2. Pre-Construct Archaeology, 2011).

Rykwert, Joseph, *The Idea of a Town: The Anthropology of Urban Form in Rome, Italy and the Ancient World* (MIT Press, 1988).

Simmons, B. B. and Cope-Faulkner, P., *The Car Dyke: Past Work, Current State and Future Possibilities* (Lincolnshire Archaeology and Heritage Reports Series No 8. Heritage Trust of Lincolnshire, 2004).

Stead, I. M., *Excavations at Winterton Roman Villa and other Roman Sites in North Lincolnshire 1958–1967* (Department of the Environment Archaeological Reports No 9. HMSO, 1976).

Stocker, David (Ed.), *The City by the Pool* (Lincoln Archaeological Studies No 10., Oxbow, 2003).

Wacher, John, *The Towns of Roman Britain* (Book Club Associates, 1976).

Whitwell, J. B., *Roman Lincolnshire* (History of Lincolnshire Vol 2. Society for Lincolnshire History and Archaeology, 1992).

Willis, Steven, *The Roman Roadside Settlement and Multi-Period Ritual Complex at Nettleton and Rothwell, Lincolnshire* (The Central Lincolnshire Wolds Research Project Vol 1. University of Kent/Pre-Construct Archaeology, 2013).

Witts, Patricia, *Mosaics in Roman Britain: Stories in Stone* (The History Press, 2010).